D0515709

TONY OURSLER THE INFLUENCE MACHINE

ARTANGEL, LONDON / PUBLIC ART FUND, NEW YORK

-31 OCTOBER 2000 MADISON SQUARE PARK NEW YORK 1-12 NOVEMBER 2000 SOHO SQUARE LONDON

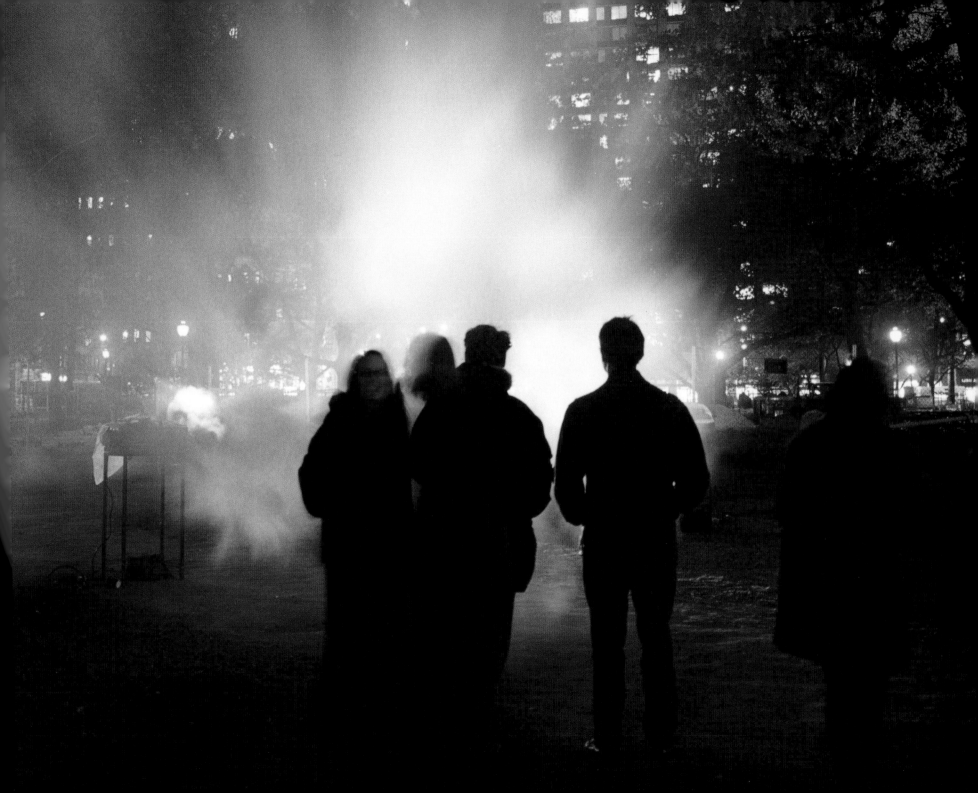

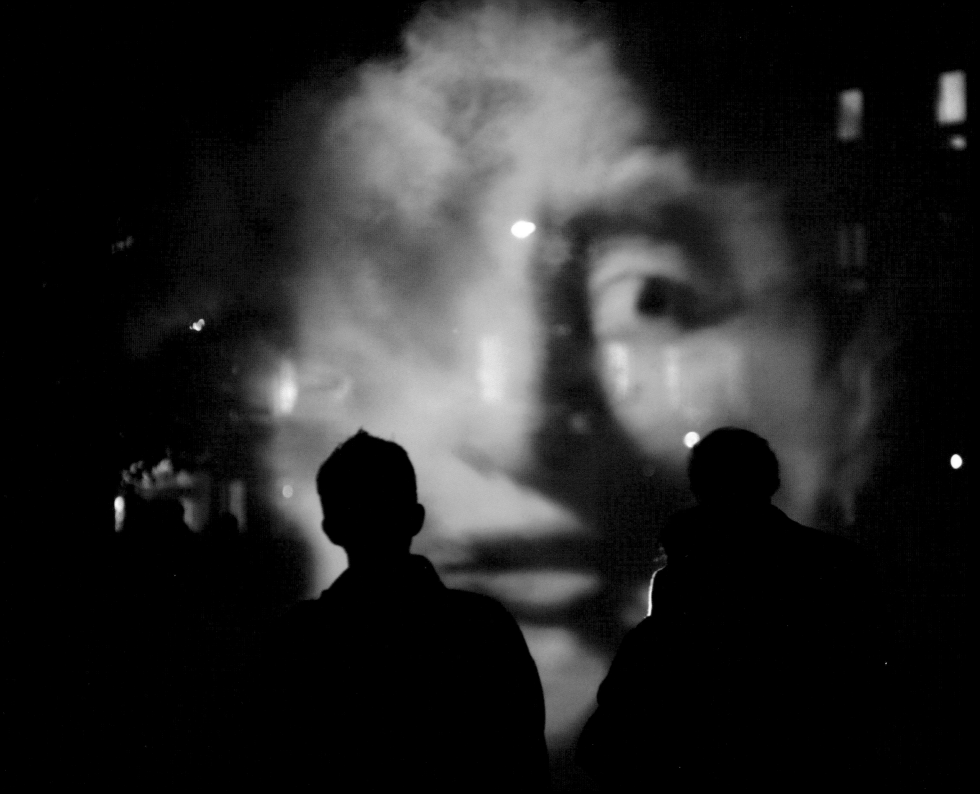

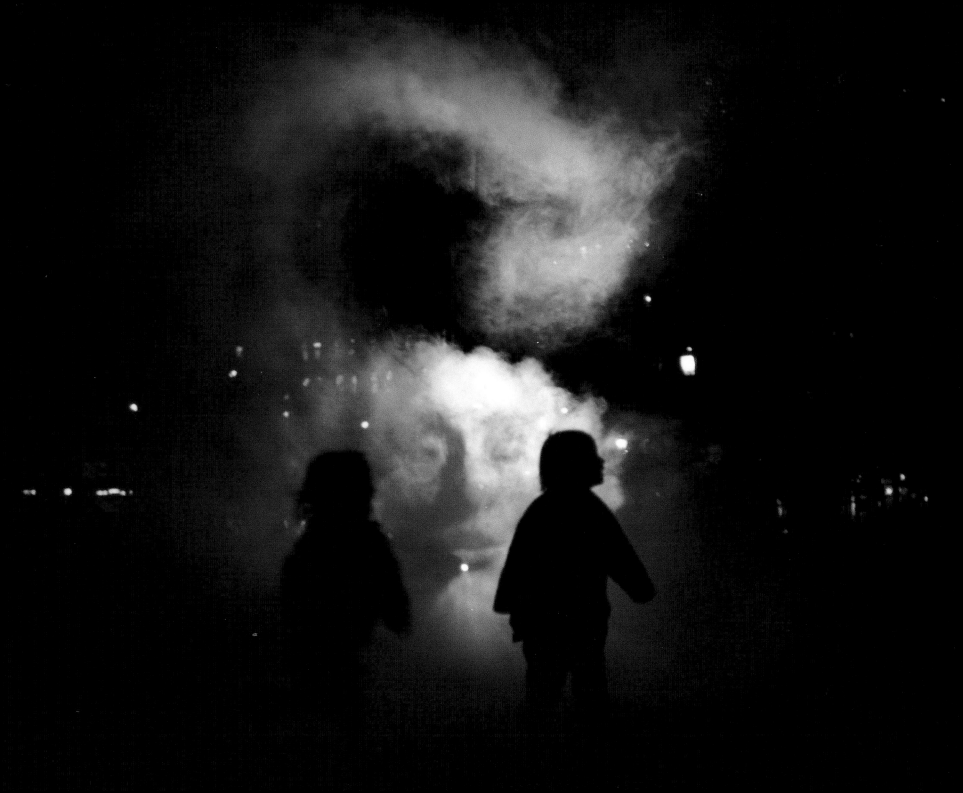

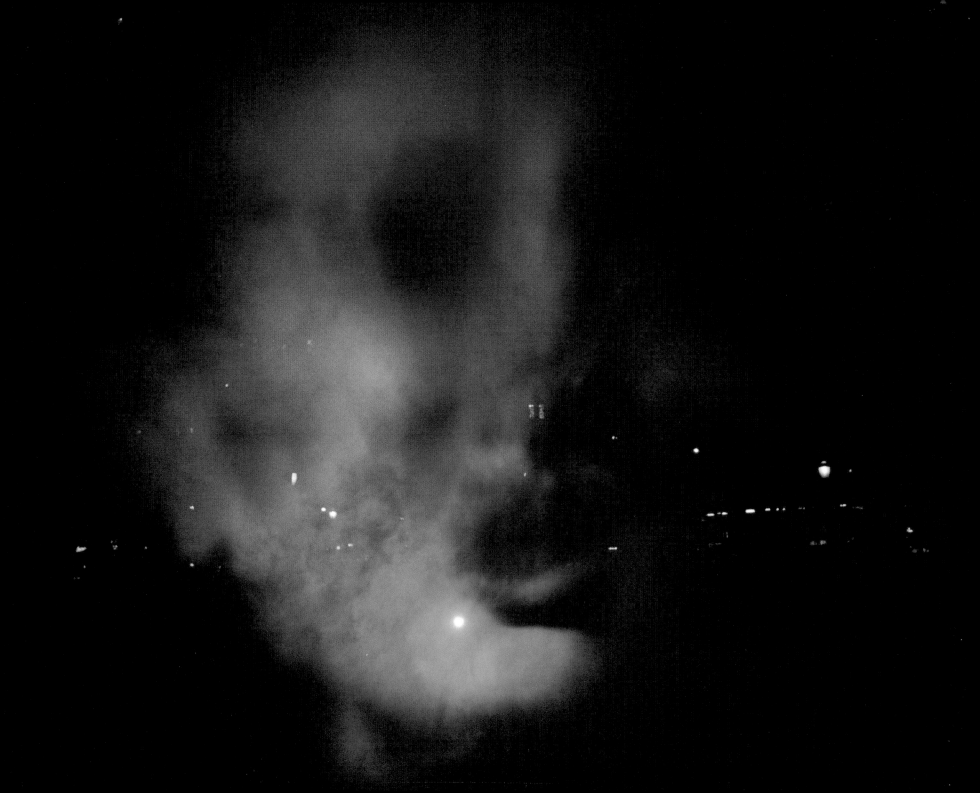

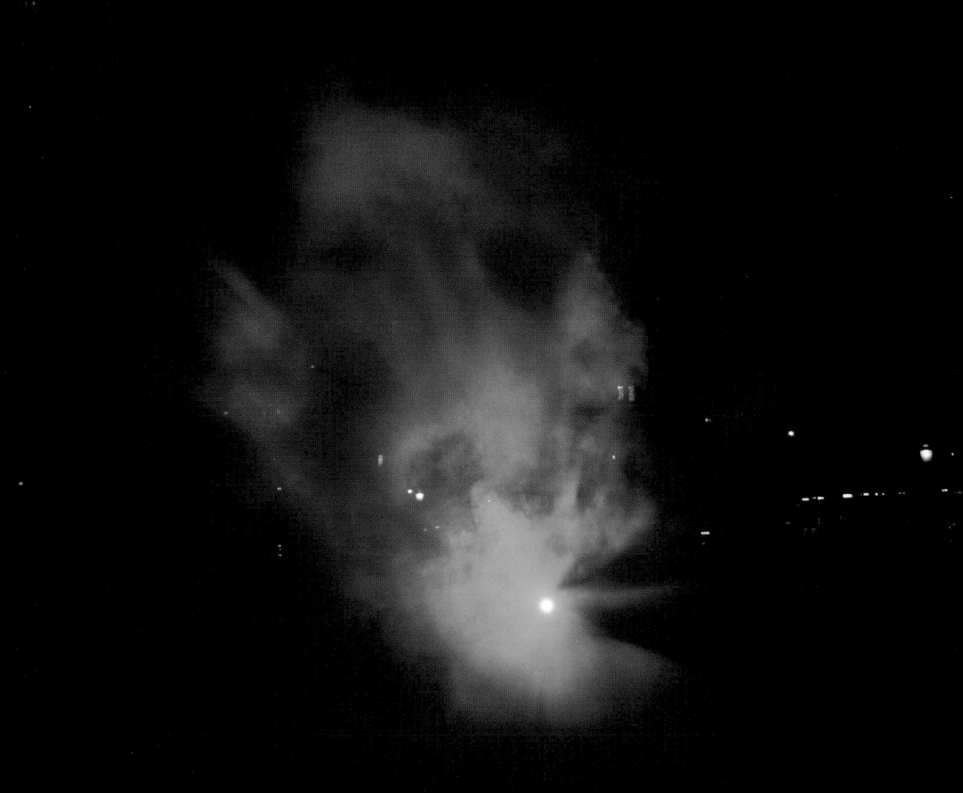

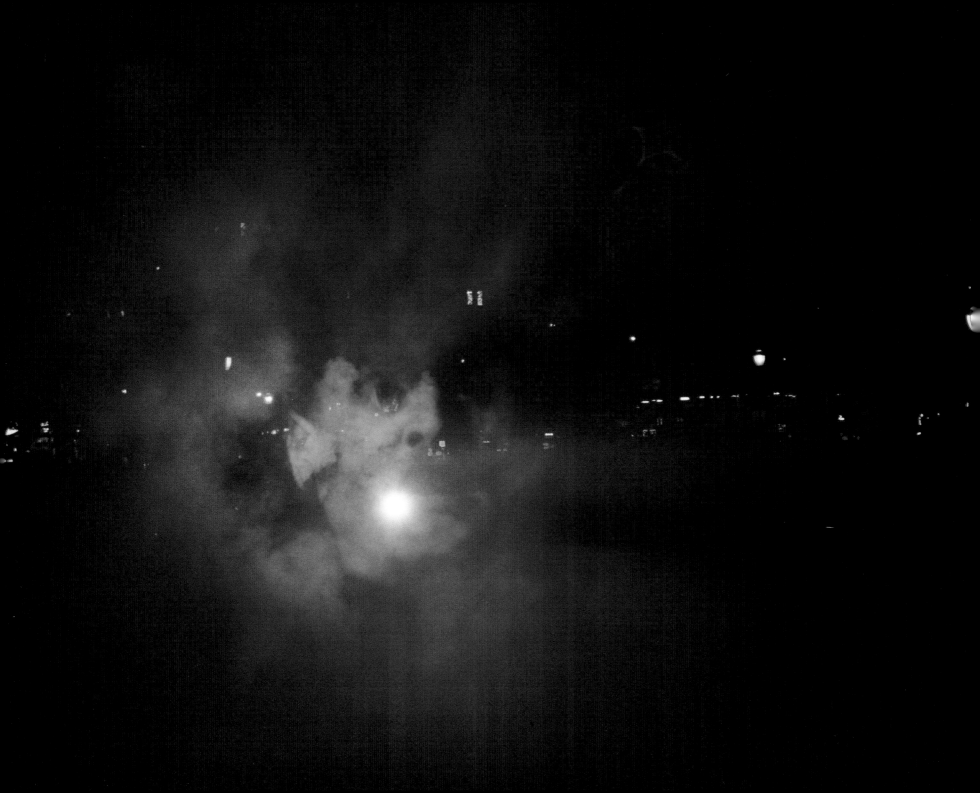

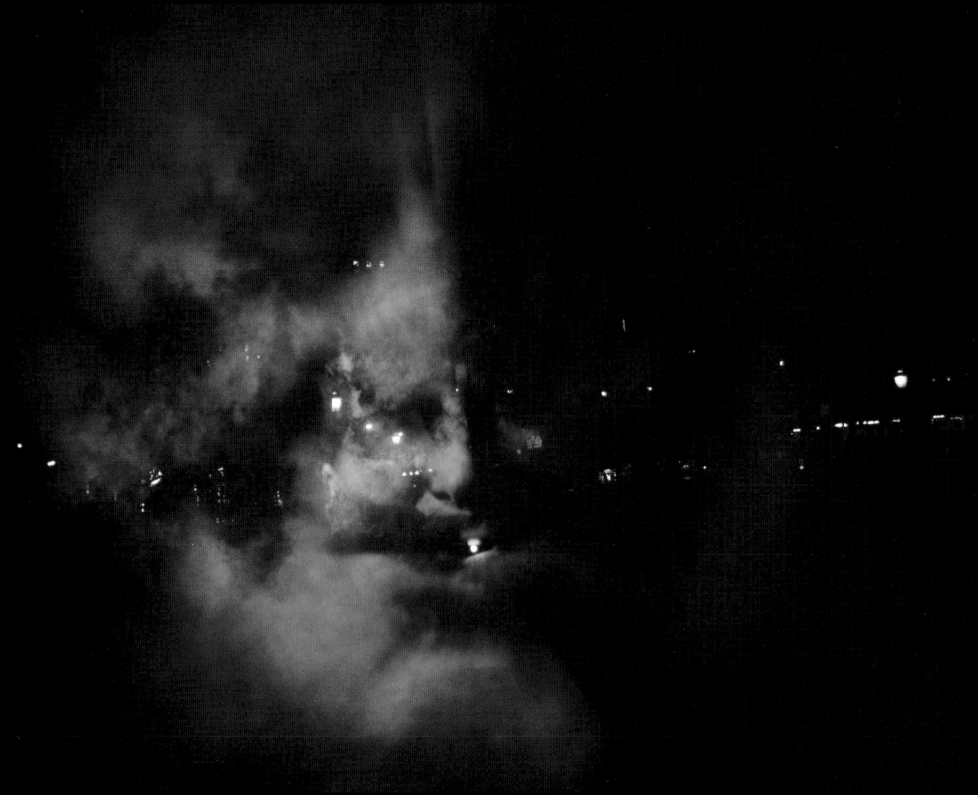

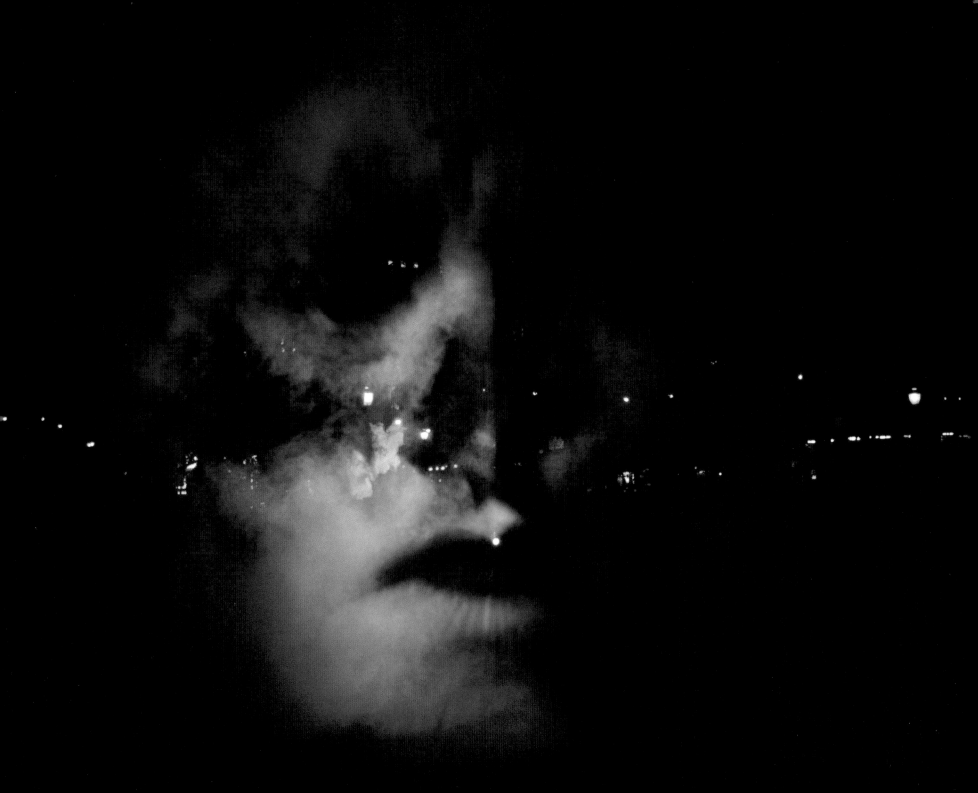

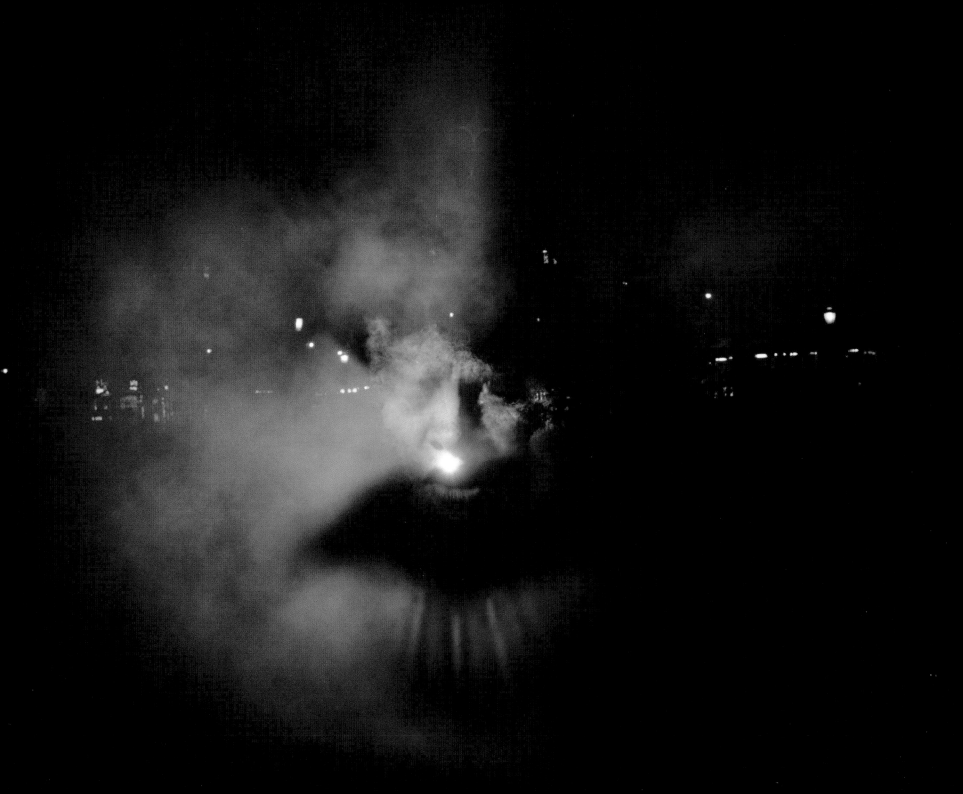

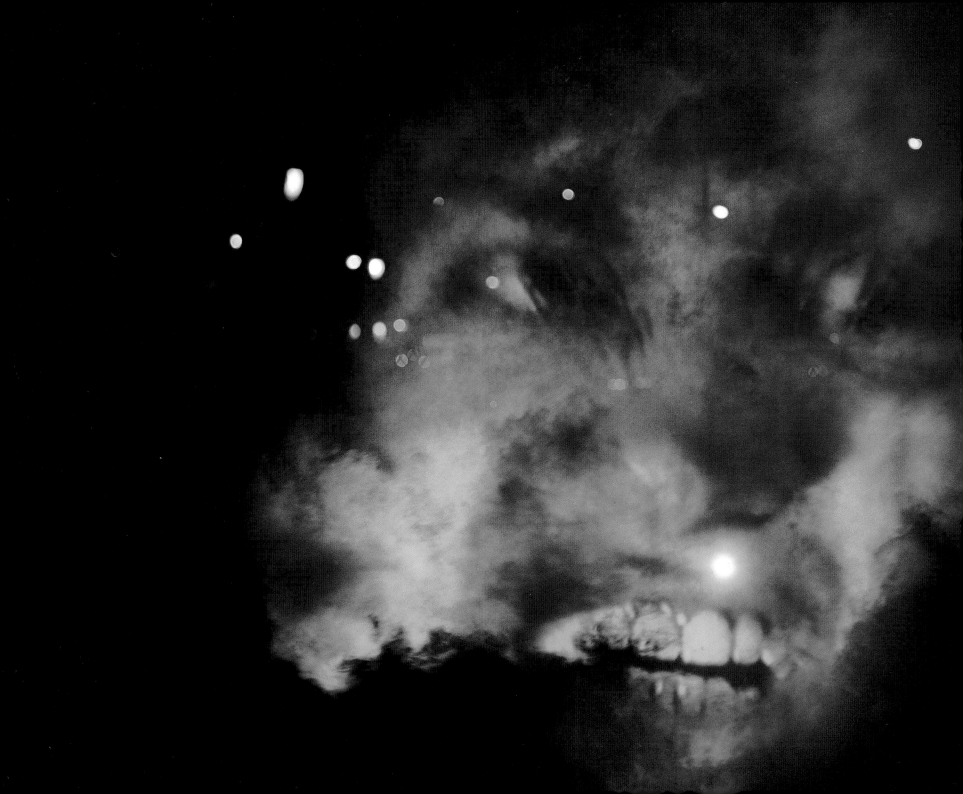

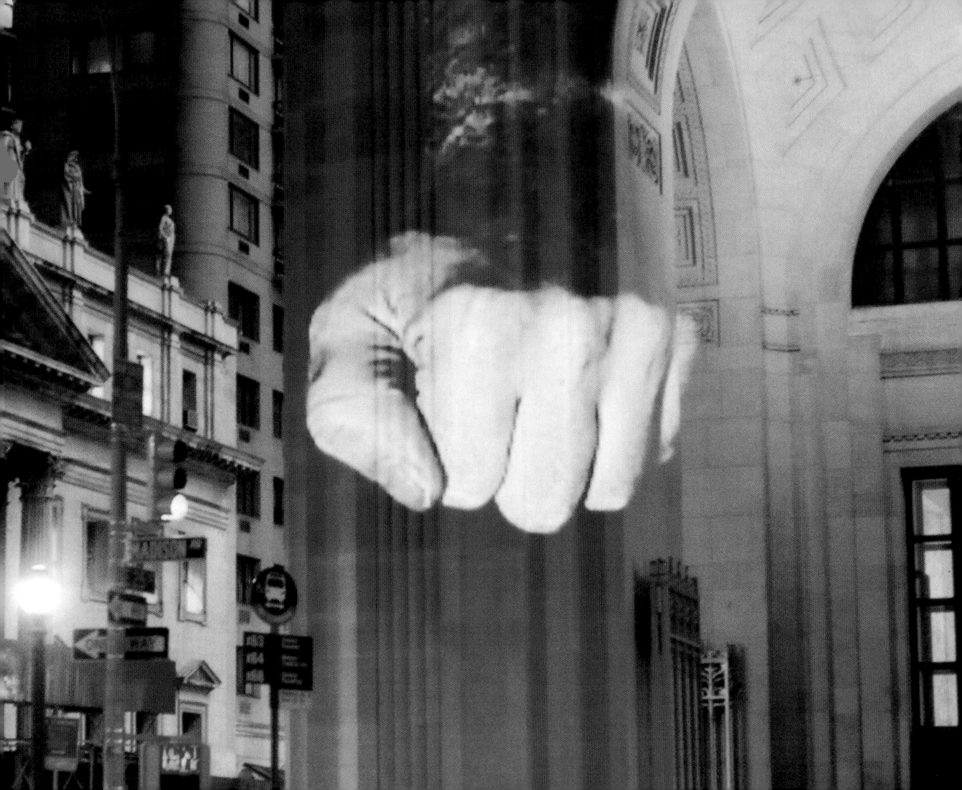

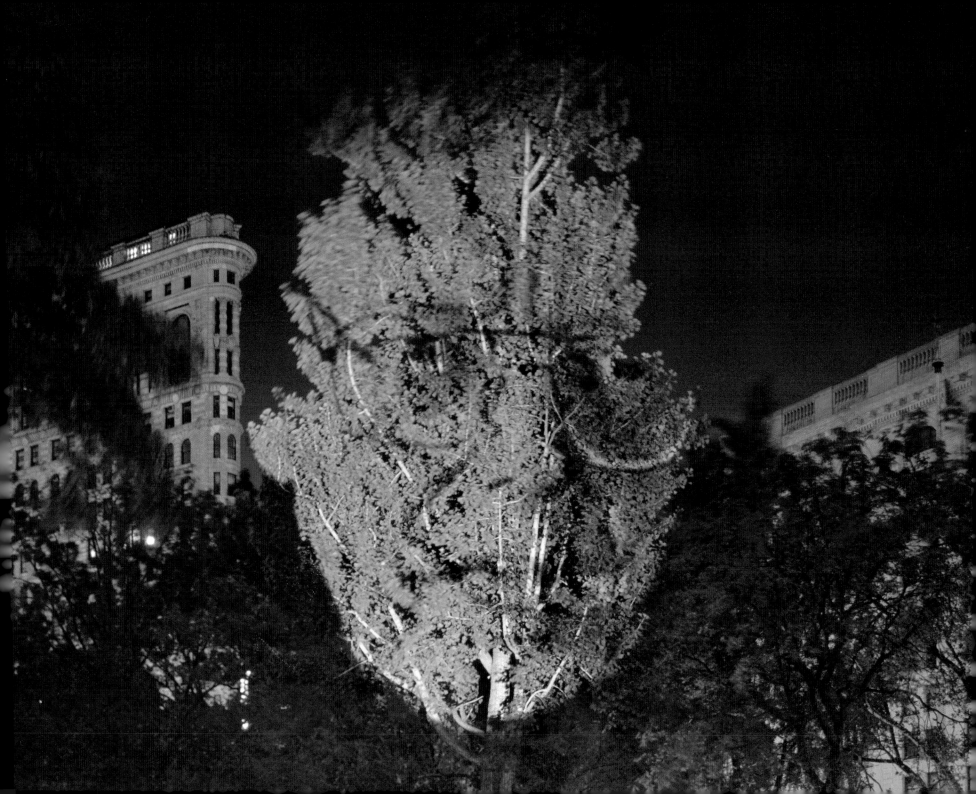

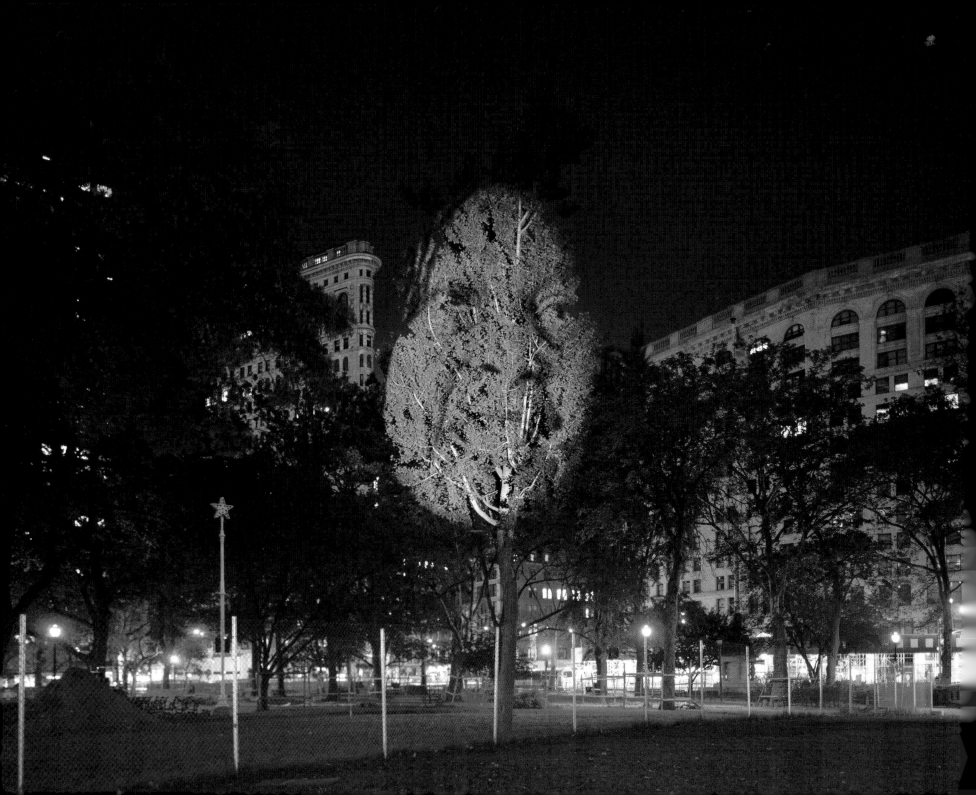

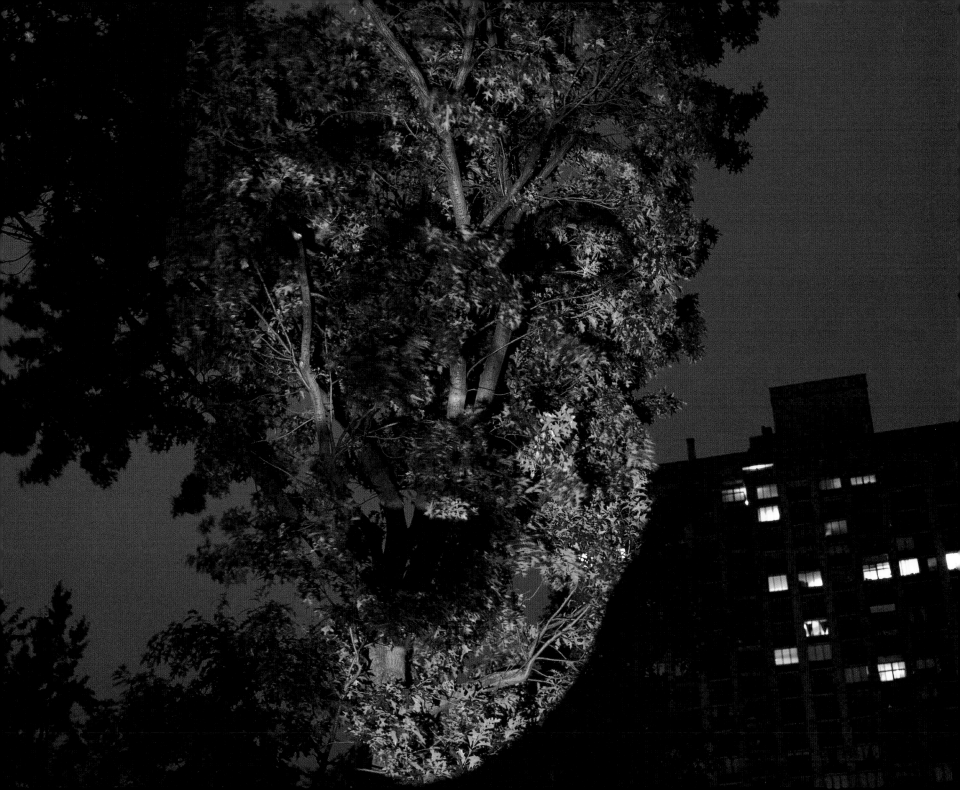

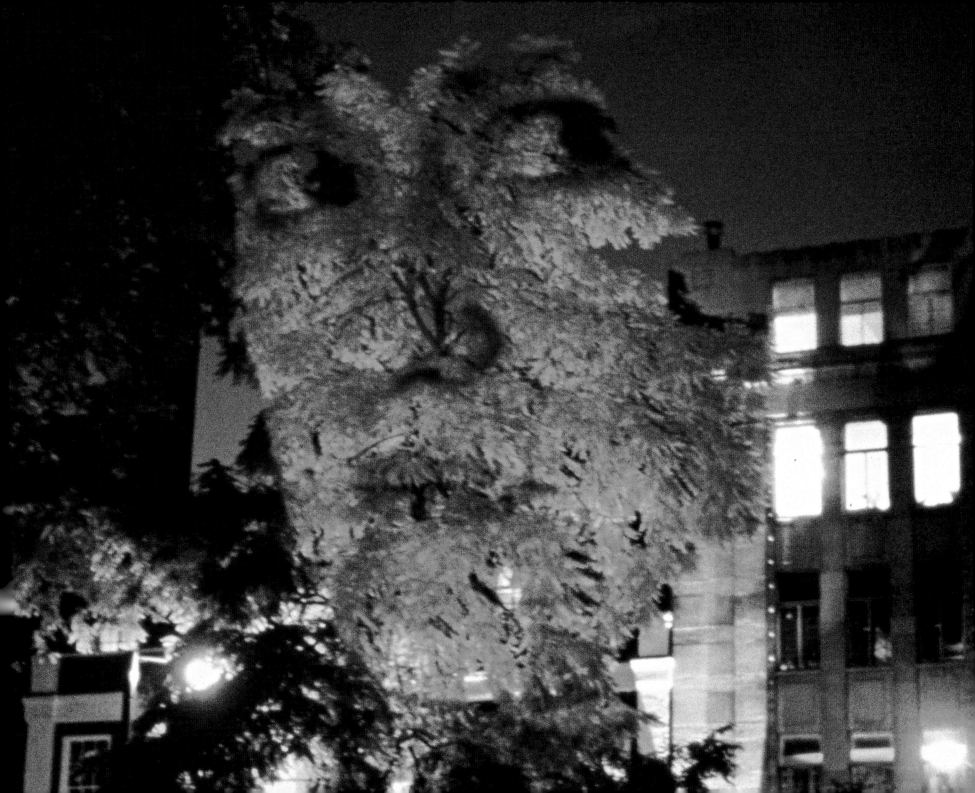

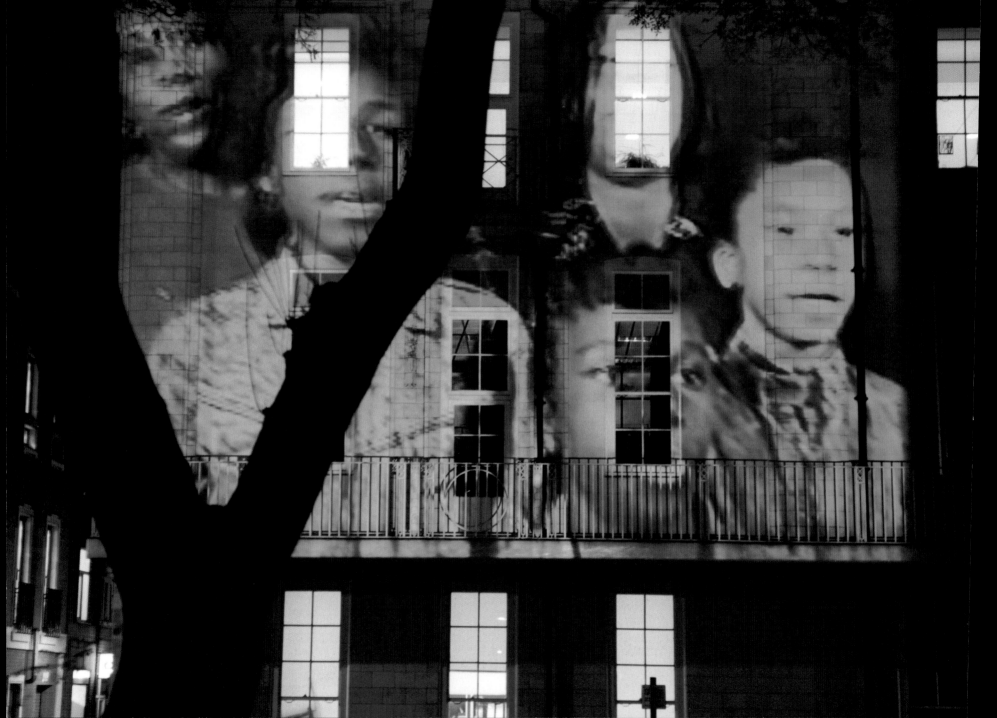

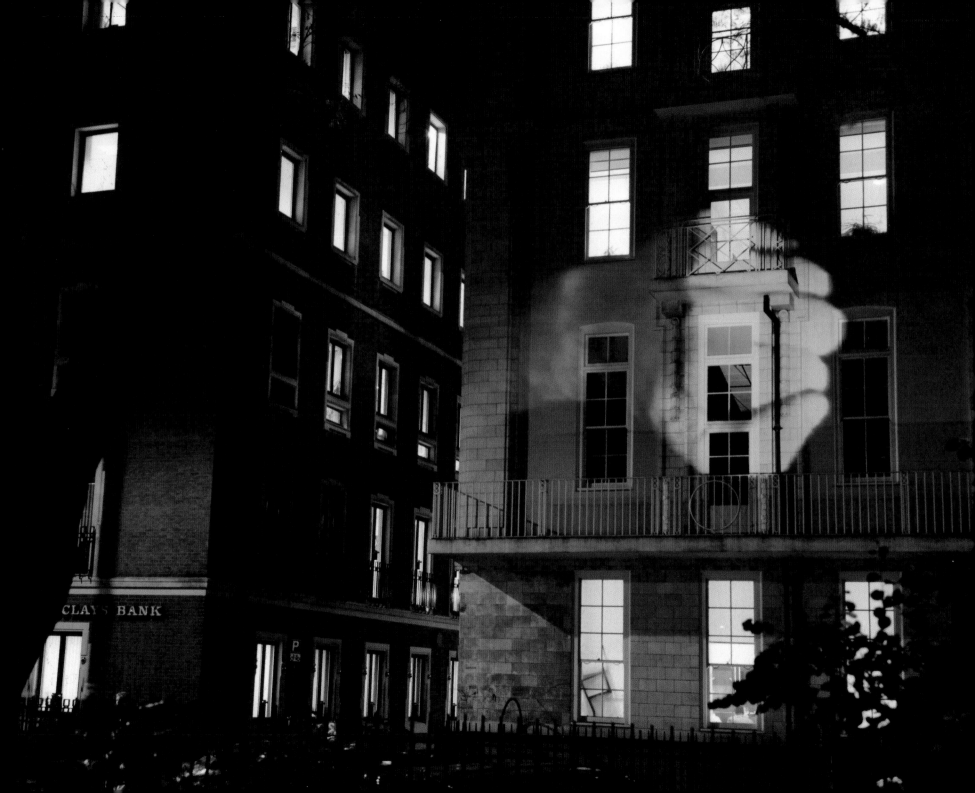

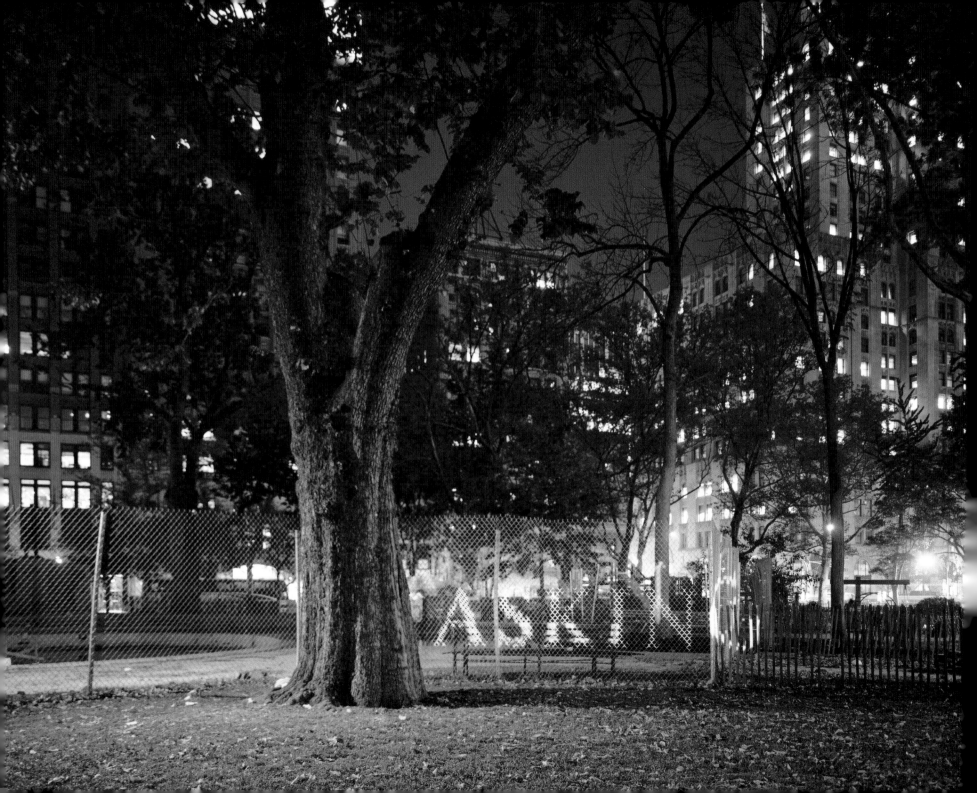

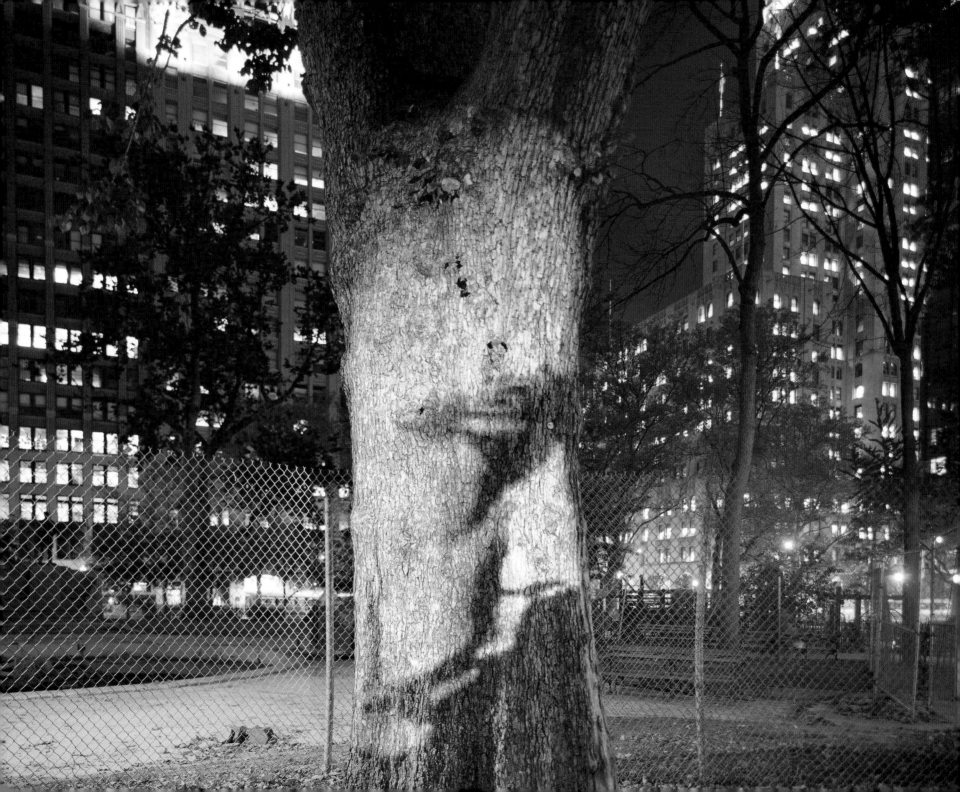

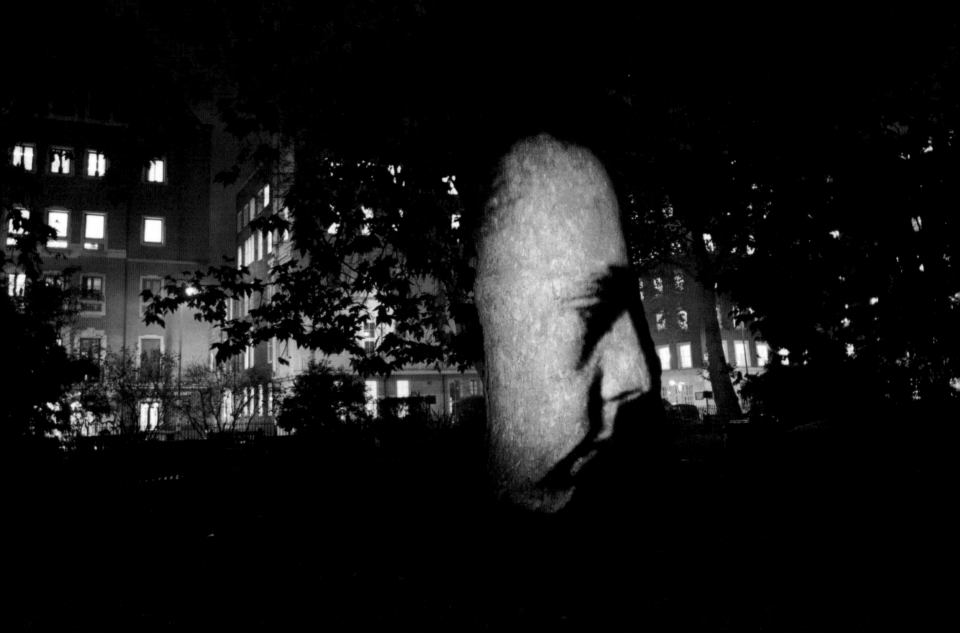

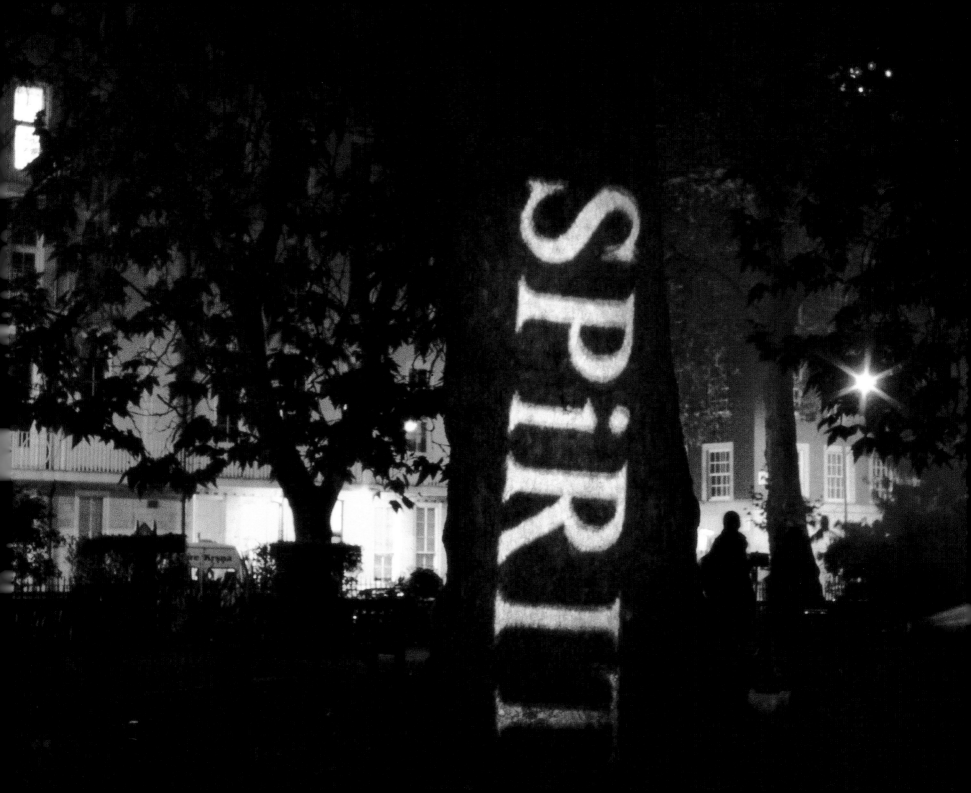

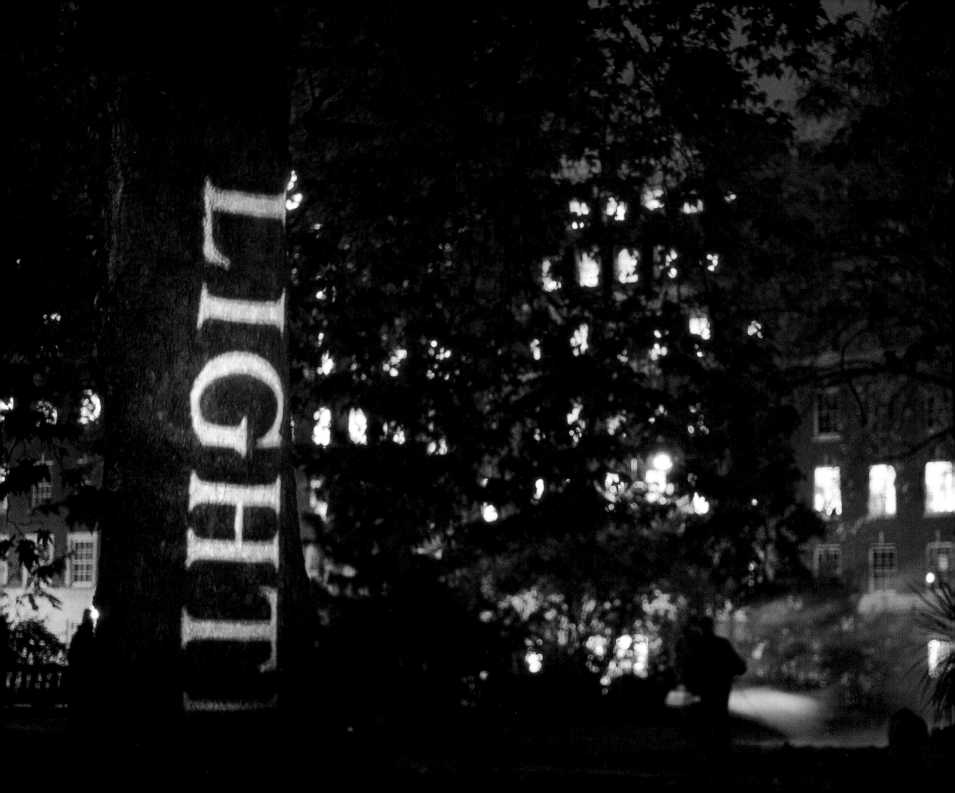

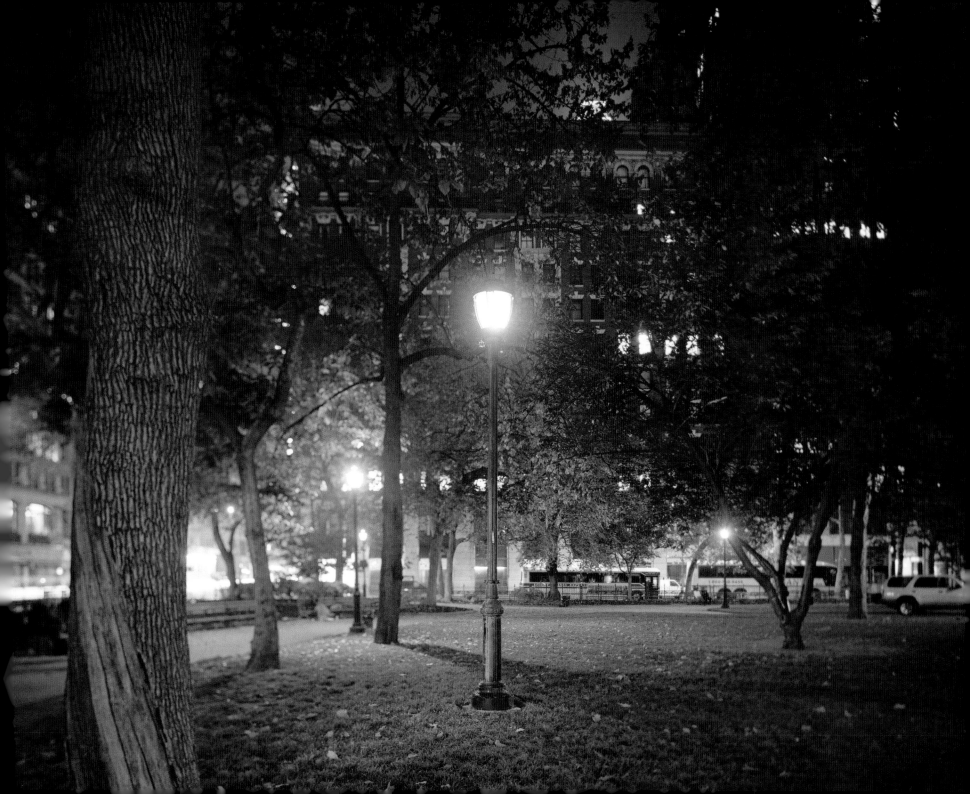

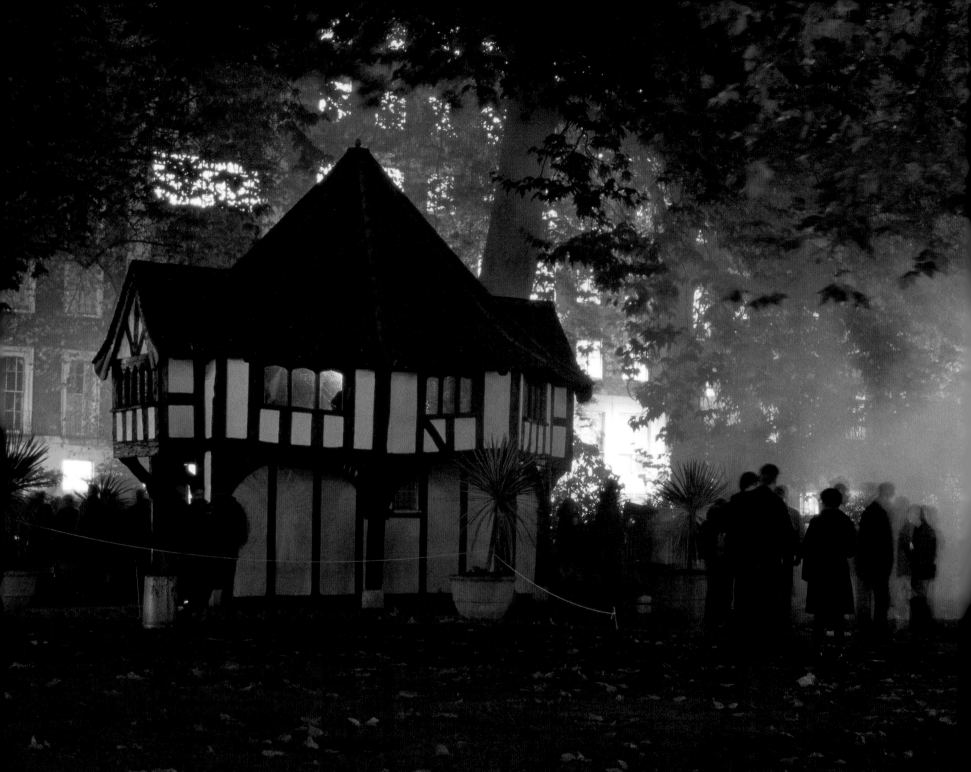

WHO EXACTLY ARE YOU?" 63&$@*^vuo5%9

LIZE ITC we r I'm contacting you v v

space there on it... ENERGY IS EASILY

event for both sides... are you readir

$%^&‡‡$!@*&^ LOSS OF QUALITY interfere

RE U THERE?? LET'S DO THE COUNTDOW
the drive THE HARD DRIVE sorry to tak
ECTED THERE /.]>.~.--mmmm... what a mo
e? ooohh bbbaddd czevctionn I'm sett
WE HAVE BEEN WATCHING YOU ufejhcdh

CONTENTS

Medium

MONOLOGUES

BY TONY OURSLER

let me introduce you to... "Mr. Blank"... "Mr. Blank"... I'll be who ever you want him to be mutated materialization Farnsworth Baird Robertson all mixed up slicing sucking soak up smoke dissector YOU again SPEAK: all lines converge all space collapses all everything from here to there around and inside the whole thing cuts right through it past your mind past your head a hole a point never can get to it keep walking go on and on off to the horizon day into dark spots in front of your eyes cut to it vanishing point"... Oh boy, the Inventor... lab set up over heated experimental station noise LOOK LOOK lights so hot hot hot hot (cough) burning I smell something (cough) camera eat it up camera eat up heat up camera eat your head up... I'm not a talking head... I'm not even here... there... my lips are moving... my voice... is coming out of the machine... machine? oh no machine time all used up oh lights are so bright you faint you melt you fall you down you go boom lose your mind lose lose lose your body yes good transmitter transmitter transmitter I've got a vibration here and it wants to make a contact? gentlemen he wants to speak he wants to speak to you may I speak to you? Thank you: "this is John Baird over here electric charged when struck by light uppsy I blew a BLOODY fuse all lights are out YOU CAN SEE IN THE DARK use animal eyes victims of vexing vapors charge discharge empty thoughts wash windy flat wandering light sensitivity of the eye, visual purple the eye shadow ha ha ha it's ok now purple come out purple inside inside out visual purple the light receptor of the eye" pop I've got to get some air I'll be back later... YOU CAN SEE telepathically lets see the little boy... oh how cute... their is always a little boy... girl... something like that... mommy mommy I'm here don't leave me... I don't know OH yes here we go "there is an other woman in my life her name is television soft skin a light sensitive surface Spirit telling me drain drain drain off the static" Time... Time give it to me ha ha ha I'm hungry aaahhhh yyyeeesss listen to that NOISE I can't think Hey stop talking through the lady... reception is fuzzy frantic yes... I want to show you something come here a little closer a real picture of how it is RCA BBC its a rip off!!!! (cough) wars fires smoke mirrors get in the way of your pleasure wait I'm getting something Your going to love this hello what I can't here you what your breaking up (cough) "the tube blew out are you frustrated I'm sorry it took so long" transmitter transmitter transmitter Mr. Blank: "the difficult we do at once the impossible takes a little longer" it is not sharp and clear and well defined oh darn it crashed mommy mommy I'm here don't leave Time... Time give it to me ha ha ha I'm hungry aaahhhh yyyeeesss "Farnsworth's lab is on fire" What? "Farnsworth's lab is on fire" What? I can't here you wait I'm no I can't it's not your all distorted the invention is out of control "monstrous? no amazing" Hey I just tell it like I see it this is a beautiful interment Please answer the question

will it work? inventor get back to the drawing board If your so smart where did
i come from? the NOISE everywhere Oh no I've got to recover from a nervous break-
down... picture quality gradually improved No! not again! "I'm Mr.Blank I've got
a secret TRK-12 you figure it out"... I'm just telling it like it is. I looked,
I saw... but I have no memory mommy mommy I'm here don't leave me...

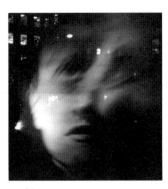

Medium

I'm getting something... R R R its not a name that i can say... speak of the devil RRRRRRobertson trying to speak to you... The First moving image theater Paris crypt 1700's P P P Pantasimagoria go in you go in see it moving I'll let him speak "It should not be moving, terror inspired shadow characters occult lost in the immensity of space celestial light go into it the crypt see the light: Sad, severe, comical, kind, weird scenes major apparitions"... are you lost in the dark? No, I can't say it... R Robertson? where are you? I'm going to kill you... Ha Ha Ha He wants you to know this... "Alone Together You lose your body Don't think individuals v.s. masses Oh Occult Optical Objects great men were pressing round something small before your eyes eyes eyes effect t us in special ways v.s. feelings we have already experienced Don't think Subjectively difficult to bringing together various opinions facts" R R Robertson wants you to know this... Don't think Watch Don't speak of the devil RRRRRRobertson petitioned the devil Control Past Destroy Future Devil familiarize you objects lost in the dark?

coming through 1920 Scottish invented mechanical TV BBBB BAIRD coming through not connecting clearly... hot, smoking, light burning, actor out, use dummy, off comes the head... away sweet body broadcast dummy jump for joy Life coming through the sky Life coming apart puzzle pieces Nipkow disk dissect the picture pieces by piece pixels puncture space NEAR IS FAR — FAR IS NEAR weather trouble Wow all the parts comes back together again! Oh no something is wrong... that thing's not alive, its all electric... I'm losing reception... Now it comes, person pushes things as far as they can go push push until it falls apart, metal fatigue, organ failure, weak signal, well OK you tried... Lay down and give up the image Oh no very very crude vague pictures A BIG BLACK BOX with everything in it. That machine is made of junk! Noise in Noise Out Where is everybody? You receive the picture You are here I am there you are gone... POOF! My HEAD what happened to my head separate from voice flesh far far far away thoughts... where are my pictures? Close up Long shot Bellytalker Body skin Flat send it away boom banished to everywhere... where we all think the same thoughts unified mirror mind magic same time same station Always on Camera close up close down spectrum sucker smoking hot lights don't look at it moving cold glass tube Bad weather... I'm getting a presence sounds like FFFFF PPPPP PHILO T. Fansworth — little boy thinking flat lines fields Idaho go on forever first Electric Television image: luminous line... all you ever see is shadow smoke... make a face for the c-a-m-e-r-aaaatmospheric conditions picture sooooo bad, transmitter bitter receiver burn electron stream TV eye across barren fields... Fun and Games, Fun and Games thief of time a cold wind will blow across empty space..

Where are you? I am getting a message From a mental institution 1933 Doctor Tusch
has something to say about influencing machine: Machine is hopelessly complex mental
construct Machine invisible controls remotely makes patient see pictures. Machine
is patients body Machine produces and drains off thoughts feelings enemy manipula-
tion of apparatus is obscure. The machine controls your body this is accomplished
by suggestion telepathy air-currents, electricity, magnetism, or invisible rays.
Limbs, face, facial expression, thoughts and feelings are estranged You can't
construct the past you can not destruct the present the machine doesn't work it
can't work it looks like it works but it's not the whole thing goes up in smoke you
are good look around you are bad oh no you broke the Telepathically Machine you are
a stranger to your self does it have a head? oh you don't know do you... Who does
the machine look like? you can't say can you... What ever you do to the machine you
do to me... Don't remove the genitals body collapses into two dimensions vanishes
now the patient claims it was never there

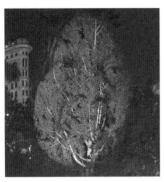

Chorus

Knock Invisible Knock Invisible Knock: Who's there? i'the name of Belzebub? Knock BANG Apply force to object BOOM violent waves move through matter one medium to another energy dissipates tap tap rap rap spirit sounds sequence cypher into message: Visible1848 Hydesville NY Kate Fox age 12 hears a rapping in her bad bed Snap her little fingers "Here, Mr. Split-foot, do as I do!" Knock Knock knock Held up three little fingers Knock Knock Knock "Look Momma, It can see as well as hear!" Rules of Order when Communicating with the Dead: Question Spirit. Spirit answers two raps signifying Yes one rap signifying No. Three neither Yes nor No, not now, not yet, don't know. Five Alphabet. Continuous error. Knock Sounds have nothing what so ever to do with physical body. KnockSpirit bang spells boom: "L-O-O-K"

Invisible message Visible
Go thou, when life unto thee has changed,
Friends thou hast loved as thy soul, estranged
When from the idols thy heart hath made,
Thou has seen the colors of glory fade;
Oh! painful then, by the winds low sigh
By the voice of the stream, by the flower-cup's dye,
By a thousand tokens of sight and sound,
Thou wilt feel thou art treading on hallowed ground.

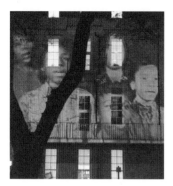

Chorus

Knock Dot Knock Dash weak wire wander magnetic codes live like a spider along the line Zap receiving mechanism make a dark mark finger moves fast the frogs leg jurks the little girl makes a knocking sound Listen: _._ .._ ._ _._ . ._.
. .. ._.. ._.. . ._. "Kuaker" Killer "Kuaker" Killer "Kuaker" Knock Knock who's there?
Truths revealed by those in the Unseen to those in the Seen static skipping surge currents cables consciousness dizzy open atmosphere little voice wandering lost and alone tap tap rap rap from far away wire wonders: What has God wrought?
Dot Knock Bang Dash Boom HELLO? HELLO? is anybody out there? Kate Fox? stop the voice listen lines quickly crossed violent tapping (knock knock) yes (knock) no: Hear... Mr. Split-foot... do as I do (clap clap clap) Mr. Split-foot can you count to ten? How old are you? How many are alive? How many are dead? the dead? the living? how do you separate the two? NOW HERE THIS:
sssssssssssound transmitted so called dead send joyful tidings that all still lived, still loved with human tenderness... electric angel guiding helper looking out...
HELLO? HELLO? bang bang Knock knock Kate Fox stop clocks hoax! hoax?
HELLO MR. SPLIT-FOOT... little girl talk dead no wire...

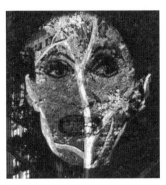

Chorus

(viewer fragmented the death though dream) MY dreams are your command stop flow images out of me me me look at me oh that feels good I'm negative I'm positive In and out and back to me all the possibilities scene by scene OH NO there goes my body again poof! gone stop start poof! here we go again go fear of death there is no death, body death? I am your perfect match no death, what's the big deal death do it to me death blue blue aye good now the spirit organs do it. swarm of energy feedback system I am what ever you want me to be. I hate to break it to you: It's the same here as it is there it never ends problems solved unsolved immortality the human personality and its survival after body death lets dream it up transition after we die what then? I'm canceled out Electromagnetic Etheric Systems Approach to Communications gone I'm gone far away bring me back to life please, I want to be you you you catch me caught inside, inside you, I can hide, let me hide, inside I'll be quiet... I'll be watching... you catch me from the light through the lens through the eye through the air POOF! I am no longer there — air flare electromagnetic radiation shifting higher and higher all the way to the color red dead detached head bled of life, now it comes back, black black black black is the color of my eyes I can't see you, where are you? Signal is weak! where are you? Fading Oh No Snake's alive scanning pixel by pixel, point by point, flash by flash, deeper and deeper into the shadow, snaking sucking it upside down, come out of it dream victims of vexing vapors charge discharge empty thoughts wash windy flat wandering hollow glass light sensitivity of the eye, visual purple machine ha ha ha it's ok now purple broadcaster of the afterlife come out purple inside inside out

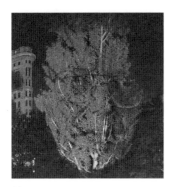

Chorus

This is William alone with a problem trying download "Doctor Nic" surf spectrum clear electric ocean channel U-R-L Doctor Nic open dot closed enter me Question I am here and you are?...

Ok Bill, Doc Nick helper here do you have power I'll give to the message count let me in down 10 987654321: Mary — had a little lamb — fleece was white as snow. Everywhere Everywhere Everywhere that Mary went the lamb would gooo-ooo gooooo-oooo.

Doc Nick? a lurker? (garbled) Everywhere Nowhere... No, I'm the lurker! Doc you have to admit it's scary communicating with the so-called tune the machine dead Problem I am here — you are there — I am here — you are there... hello, hello

Bill don't worry click I'm here and I have to tell you Bill I'm doing better than ever! choose all down drop drag me, Message: there is a time and place for everything. TIME PLACE I want you to remember this Bill. Thank you I'm free visible invisible all of this stuff is cool coming out outer limits depleted state don't break the circuit hurts burns out of me the trick — linger a while in your own atmosphere — we are watching your thoughts, they are many and shadows of anxiety seem to throw gloom over you What did you say? I am always with you.

No where did you go Oh its late over on this side Doctor Nicholas dark night.

William You know better than that. ahh you know I'm no aware of serial time over here.

Yeah I'm just joking ya doc. Seriously one more Question: Is the soul free of the body after death?

"Ta nav, Billy"

what? say that again

"Ta nav, Villiam"

Everything has a time and place except you Doc

NNNOOOOO! I'm not dead! I have some words and pictures information not buzzers and lamps smoke and mirrors electromagnetic ocean translation of life into 0 1 TV Site Program, show I'm still alive aaaallllllllliiiiivvvvvee. Well they say I'm linked to technological developments evoked projection of your unconscious mind Bill what do you think of that?

Sorry hhaa Doctor I'm just joking hhaa hha I don't look at you as a show movie this communication is important to me.

Great, Play that back for me will you.

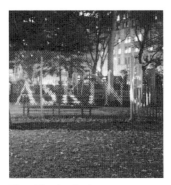

The Technician

"WHO EXACTLY ARE YOU?" 63&$@*^vuo5%9O ARE U THERE?? LETS DO THE COUNTDOWN STABILIZ
ITC we r I'm contacting you v v via the drive THeE HARD DRIVE sorry to take up space
there on it... ENERGY IS EASILY DIRECTED THERE /.]>.~.--mmmm... what a momentous
event for both sides... are ypo reading me? ooohh bbbaddd cxevctionn I'm getting
some... $%^&#$!@*&^ LOSS OF QUALITY interference WE HAVE BEEN WATCHING YOU ufejhcd
w e we are ALIVE hjeksdjd60@$5%(**$!@%$(^%ED1momy I'm here don't leave me mommy
I'm here don't leave me mommy I'm here don't leave me 13 WHATCH ME NMOTHING MOVES
163$#7411342^#@52U 67 SPiRIT TIMESTREAM ouytfv34687(&64I went missing on MachH 20
nineteen ninty9 weee have formed this team TO CONTINUE THE WORK WE STARTED ON UR
SIDE!!!(^%ufjhf35526 TYPE BACK to me the KEYBOARD though the KEY the BOX a MULTI-
TUDE of LIGHT

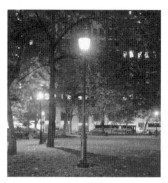

Talking Light
(excerpt)

Telecommunication systems such as Morse code, radio, telephone, film, television, and the internet can be seen as products, or, extentions, of your mind. These systems mimic our perceptions of sight, sound and language! These systems help your mind do what it wants to do! What, does your mind do? What, does it want to do? Change, into something different? Play? Be many places at once? See everything? Communicate, to people, far away?

dark texas

in the silence of my studio,

I observe the birth of dreams,, we are all candles, without wicks to burn, and our thoughts branched out, like trees............. modcult, above madison square. I love you, francis, come to the Gurrsshwin hotel!.
hi..
it can be important to conciider the fact that you don't know me

word, NYC,
i'd like to hear you,
but, i imagine i can not,

i turn around and realized
[through all this urban chaos]

this is life
and, i am simply in....... message end.
Telecommunication systems are paradoxical in that they show us signs, pictures, sounds, and language, of the worrld, yet we are, in some way, profoundly, disscon- nected from that world... Your mind is ingaged, yet, you are eyesolated physically, psychologically... There is a word for this tendancy, Discourporative, the Discourporative Impulse... Yes, the Discourporative Impulse describes what we all seem to be involved in: , shedding the physical body for the ehthereal, uuuutoh- pean, virtual presence, and the promises of ultimate interconnectivity. What do you think? I like the word Discourporative even though it seems fancy, it is direct and precise, you understand it, OK. You lose your body, your mind, is free.

night follows night follows night follows night follows night follows night in the dark in the dark in the dark in the dark dark dark dark dark dark dark night follows night follows night

hi. keep faith alive in your heart, and you will walk in the path, of dreams
open this spot, and look inside what you see are the centuries, what you see is, dirt

Their acts, are filthy lewd, and fantastical, and you suck the nurishment in it
swells, throughout the punches and bleeds on the the rocks, look around you and
notice that no one cares

then burn it all down, instead of
harvesting...
be brief
...
........are you having fun

Telecommunication systems connects us to an endless stream of seductive information
known as Media Culture. From the beginning, when Samuel Morse transmitted the first
coded message via telagraph, "What has god wrought?" the individual has struggled,
to retain identity. Do you feel dislocated?, Alone? Fractured Consciousness?

I.
a round peg, for a square hole — ,,,
a basic observation is, clear,
can edges be worn by powers of persuasion?
The trickster (one) ace of spades,
buulls eye! queen of hearts
on a parallel plane:
...behind mirrors,
beyond phenomenon

II.
The fantasy me
I am the sellyuloid princess!
Yes — spliced, diced, and reconfigured
sealed in smooth, cool plastic — guaranteed speed

Was it an illusion? melted water vapor.
Sleight of hand? Shape it! push it!

III.
Time cut. Insert face.

44

The exhaustive workings to make white light.
The chemical make-up is restoored, I remember it now.
It is a seasonal elation, a continual seduction.
These are the fragments.
They whisper.
... When I kiss
my Snnoowman.
message end.

Media, and it's technology, are popularly assigned the role of, medium.
Telecommunication systems, have provoked a connection to, spiritual presences.
Here you can see three historic characters evoked in this installation:,...
1) the phantasmagoria, and demonic evocations, of the great pioneer, Gaspar Robertson.
(who founded the first moving image theater, in a crypt in Paris, in 1763);...,
2) the adolescent, Kate Fox's telegraphic contact with the spirit world by mysterious,
Morse code, knocking, sounds (Hydesville, New York in 31 March 1848),...
3) John Baird, the British inventor of the mechanical television, who foreshadowed
the mind, body separation by using ventriloquist dummies in the 1920s for his first
broadcast experiments.

Internet message:\\\\\\\
,why are there so many of us, who struggle living? is it fate? I don't know I do
know that one's spirit can grow old just from struggling. no movie, dream or lotto
ticket is going to change that reality

there should be a karmic law that states, after one has lived a fruitfull life for
x number of years they are required to turn it in, and step into the shoes of the
nearest poor soul

now that is real justice.

if you cant controll your own life, how is anyone going to do it for you?

The Performers you see projected here are long time collaborators Constance DeJong
and Tracy Leipold as well as Linda Leven, Belinda Wilson, John McCausland, Sidney
Lawrence and Bill Kirkley...

everything is a matter of reciprocity......... what happens, causes something else
to happen and it goes on, and on, spreading out like ripples, on a reflecting pool
so, if I give love, hate,, sympathy,, scorn,,, or piitty,,, to you,,,, you may accep
it, reject it, ignore it,,, or give it back to me... But, whatever you do, will
be done, with equal measure, to what I have given you..... even if you try not to
respond at all, the very effort of denying a responce, will be in fact a responce..

I believe with Schopenhauer that ine if the strongest motives that leads men to art
and science is escape from everyday life with its most painful crudity and hopeless
dreariness, from teh fetters of one's own ever shifting desires................
...............Sometime's i thinkmyself a genius, but most of the time i'm brain-
dead...................your awareness is not larger than mine, and my awareness is
not larger than yours.................where is marriane moscowitz, she once worke
at a clothing store, and I met her. She exists, do you know her? you don't!!!!!!!!!!
I wake up every morning, and so does sarpists, priests and starving children......
our morals and decisions are a product of our....................,,,,,environment
if morals are based on a persons environemtn, who is allowed to judge?

you must always act on your true nature, and you can never succumb to meaningless
rules,,,,,,,,you must must always question moral rules to see if they have meaning
or purpose to you............this does not mean that you should disregard moral and
natural rules.......you....mustconsistantly strain important moral rules from
accumulated garbage from years..past.....there is no moral reason why you cannot
climb a tree, and if you want to climb a tree, go climb a tre!!!!!cutting through

grass lacrosse
algae shit

barriers
extinguish cars
beauty stands tall
walk deeply
on
sunk ground

goodbye

It sure is dark out here

Television archives store millions of images of the dead, which wait to be broad-
cast...............to the living....at this point, the dead come back to life to
have an influence............on the living...Television is, then, truely the spirit
world of our age. it preserves images of the dead whichc then can continue to haunt
us.......it also gives us the phenomenon of living
ghosts, or stars as we like to call themm
free me.......I dont know what to say!!!!!!!!!!!!
what should i say??????? Can you tell me what to say????????
I cant tell anymore!!!!!!!!!!
My brilliance is only superseded by my stupidity
Neogeo..........be true to yourself always!!!!! she had a mist in her eyes like
a fog hovering over the city....she was either trembling with emotion or she was
Irish, he couldnt tell which, but he wanted to hold her.
hi
It's not my fault,......,.will all these things we do make our dreams come true???
I left Manhatten and now i am happy.......spooky shadows dance in this disco of a
city tonight dark treats are our social currency costumes and masques parade down
the street who will you meet??????????????? A version of yourself!!!!!

Knowledge is firewood, it is enough......all-consuming thought of you

all consuming thoughts of you, creeping up on me at all hours of the night and day,
like vines clinging to brink walls, pushing away other thoughts like they were
cracked mortar between bricks, I change my position, brush them away in hopes that
sleep or new thoughts will replace them,,,,,,,,,,,,curling into the blanket at
my side like, cats, stubborn, sending out claws if I try to remove them...LITTLE
BEAR......................I LOVE YOU
all consuming thoughts of you
cute little little little bear...I dont know if there is a limit to how long our
quote can be, but this is one of my favorites and i think sooo apropos for the
denizens of this city to think about:
Our first tast in approaching another person, another culture, another faith, is
to take off our shoes, for the place we are approaching is holy; else we find our-
selves treading on another person's dream. More serious still, we may forget that
God is there before our survival. Rev. Cannon Max A.C. Warren

Cheers, hello Mark mitton! Suus here! Upsiedowntowm!
there is vitality, a life force, a quickening that is translated through you into
action, and because there is only one of you in all time, this expression is unique

SHHHHHHHHHHHHHHH..............quiet...............listen.........shhhhh..........
quiet.......listen
Park, are you well, its hard to tell....your grass may be green but your heart may
be blue are you lonely???? i have a new phone.....call mee......the opening was an
art students greatest fantasy , thought it has been some years since I have been
one...... Congratulations all around.......it rocks............Happy Birthday
Greekspice

diesel fuel (Scotland)......cigarrette smoke (bars).....mud (flea markets)......
fallen leaves (Haloween).....subway grease (New York of course)......greass (soccer
games)....perfume (3rd grade teacher)...laundry detergent (exlover)....coffee
(church hall)....marijuana (differnet ex-lover)...night air (now)

I saw your ad in Time Out NY mag, and I am looking forward to seeing the art
installation at Madison Square Park.

Can you tell me a little more about what this will be like?
Thank you

humphrey bogart and baby wanted to eat a rabbit, a big gray furry one, and raw.
what does this mean? gentle frost, sun on crystal.......her hair glances...fragrance
above shded woods.....her warm flesh in dark hollows under treefalls, her touch like
a spider's clinging, silkin thread......the Moon, a cold dead thing, reflecting
another's glory in the distant night........And your body like a burning torch,
inflames my liver to my great delight.....hello, I am very interested in your site.
and am looking forward to what this is going to say with my
email..............message end.

Margooo, my love for you is eternal.........Margooo, my love for you is eternal..
Margooo, my love for you is eternal, Margooo, my love for you is eternal, Margooo,
my love for you is eternal............

Chorus

Noise Noise Noise I am recording contact with 1450-1475 Khz tune ideal position far away from recognizable station relax relax clear your mind take a few deep breaths numbers tumble time slips Timestreams away there is air around you vibrations passing through skin bloob bone re-set the recorder to zero mark the point POOF your position in space and time all lines converge, all space collapses, ALL... Everything from here to there around inside the whole thing cuts right through it — past your mind — past your head — Hole POINT... never can get the body to it — keep walking go on and on and off to the horizon — day into darkness... spots in front of your eyes — cut — vanishing point POOF where are you? What's that sound? Hey come back here! You may ask where is here — I am streaming from inside numbers locations ALL once Utopian Dream Wasted Time and Energy All the normal things finished. Keep doing them. Noise Noise Noise Are you there? That's better OK remove the disk touch the key depress Play Nothing wait a minute now don't be surprised your ears have never seen anything pour plastic paranormal spiritside good night everybody ITV EVP Noise Noise Noise what did you say? Spircom Vidicom out of the light — it's dark in here — come out come out of the dark — you can see me — you can see right through me — I'm not here you are not here giver of light? trick, trick, trick, trick? you are so far away you are so far away going going going gone zero white noise tune it up satellite link lost the connection messed up modem Mush Mouth who picked up the phone? Visible message Who am I Invisible? Universe is teeming with them, there are no dead! Noise Noise Living Noise Dead! Electricity I'm having a little trouble getting a fix Visible speaking air goes in and out the sounds are everywhere up down no in out no up down pitch low noise megacycles My vocal chords are are being taken over by spirit trying to come into my vocal chords you try'n to Black People out? huh? Anomaly... yeah you, that's what they call it... Spirit get out of me aahh colored light coming into the voice changing the colors noise picture noise Light Box oh no low mouth giving — I'm gonna turn her off — I beam it — I mean we ran a lot of static, oh man we let you POP — I go around Anomaly around and around electric earth circles turn it off ok action is being taken vaa vaaa vooom vox voice crack crank cell call click calling noise listen voices whole world will be a great whispering wave... everyone will see and hear everyone else — you thoughts are not your own... those who have been watching the workings of your mind have suggested a sound a pattern of sound full body materialization out of nowhere a black box electronic device a fountain of energy feeding the good the bad the good the bad

you say? I am always with You... No

side Doctor Nicholas dark night... Will

I'm no aware of serial time over here

more Question: Is the soul free of the

what? say that again... "To nav, Vill

except you Doc... NNNOOOOO! I'm not

tion not buzzers and lamps smoke and

life into 0 1 TV Site Program, show I'

say I'm linked to technological develo

mind Bill what do you think of that?..

don't look at you as a show movie th

e did you go Oh it's late over on this

You know better than that. ahh you kn

eah I'm just joking ya doc. Seriously

dy after death?... "Ta nav, Billy"...

... Everything has a time and place

I have some words and pictures info

rs electromagnetic ocean translation

ll alive aaaalllllllliiiiivvvvee. Well th

ts evoked projection of your unconsc

rry hhaa Doctor I'm just joking hhaa

mmunication is important to me... Gre

Both Artangel in London and the Public Art Fund in New York create a platform for artists to explore non-institutional, often public settings as the context for their work. In their respective cities, each organization provides artists with an un-circumscribed opportunity to develop, produce and present a contemporary art experience for a wide audience that is simply impossible within a more traditional framework. Thinking outside the box, however, can be both a liberating and demanding proposition. For Tony Oursler, an artist who has consistently pushed the medium of video beyond the constraints of the television screen or simple wall projection, the proposal to expand into the urban environment proved particularly pertinent.

It is fairly common for museums to initiate exhibitions and tour these efforts to fellow institutions. Since both Artangel and the Public Art Fund have been inviting artists to venture into similar unusual territories in their respective cities, it seemed more than appropriate for the two organizations to come together at the beginning of a project and collaborate at every stage of its conception, development and realization. For Tony Oursler's *The Influence Machine*, that level of shared vision and mutual support was necessary to provide the ground upon which the artist could build his most challenging installation to date.

We are grateful to Louise Neri, whose discussions with Oursler provided the genesis for the project. Recognizing the gripping engagement of Oursler's traumatized cast of characters and the power they have to transfix the viewer, Neri suggested that Oursler might consider the spaces of the nocturnal city as an interesting challenge. At the same time, Oursler was investigating the coincidence of early technological advancements in disembodied communication – from the telephone to the television – with the evolution of nineteenth-century spiritualism and voices from the other side. From this starting point, *The Influence Machine* developed into a night-time *son-et-lumière* that combined Oursler's historical research with recorded performances, video projections onto smoke, trees and surrounding buildings, and sound installations including

INTRO — OUT OF THE BOX
SUSAN K. FREEDMAN, TOM ECCLES
AND JAMES LINGWOOD

a 'talking lamppost'. The result was a beguiling nocturn haunting of two particular city environments, Madison Square Park in Manhattan and Soho Square in London. Images of knocking hands were projected onto trees an nearby buildings with corresponding knocking sounds alluding to Morse code. Texts ran over construction fenc and trees, pronouncing intimate and cryptic messages. A human voice emanating from a lamppost (in New Yo and from a cottage-like folly (in London) with a synchroniz blinking light transmitted messages provided by the publ through a dedicated web-site. In addition to the artist's narratives, the soundtrack for *The Influence Machine* includ segments of radio feedback, the unusual sounds of a gla harmonica performed by Dean Shostak, and a score b Tony Conrad commissioned especially for this project.

All of these elements as documented in this book are h torically rich with references to early technological develo ments. The knocking images and sounds are based or a nineteenth-century adolescent mystic named Kate Fo who contacted the spirit world through a mysterious Mo code of knocking sounds. Other texts reflect historica figures like Etienne-Gaspard Robertson, who founded the first moving image theater in a Parisian crypt in th 1790s, and John Logie Baird, the British inventor of th mechanical television, who used ventriloquists' dummi rather than actors for his first broadcast experiments in the 1920s, which received their first public 'airing' in Frit Street, only a hundred yards away from Soho Square. Collectively, these elements indicate the human proclivi for assigning mystical properties to technology, which becomes increasingly relevant as contemporary society finds itself constantly engaged with the telephone, telev sion and the Internet throughout the course of daily life

The scale of *The Influence Machine* demanded the involvement and dedicated efforts of many individuals, not least Oursler's longtime collaborator Constance DeJong and the actors engaged by Oursler for the narra tives of his installation: William Kirkley, Tracy Leipold, Linda Leven, John McCausland, Shamel Moore, Belinda Wilson and the Wilson family. In New York, the comple

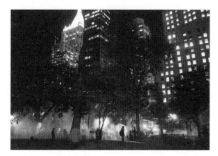

The Influence Machine, Madison Square Park, New York

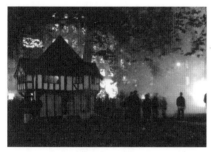

The Influence Machine, Soho Square, London

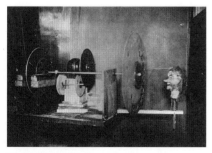

John Logie Baird's dummy

production and installation of *The Influence Machine* was ably managed by Zoe Pettijohn, of the Oursler Studio, and by Richard Griggs of the Public Art Fund. The installation in London was made possible through the technical management of Simon Byford and Simon Corder, and Melanie Smith from Artangel, assisted by a team of technicians and invigilators who braved not only the haunting ghosts of the Fox Sisters and John Logie Baird but also the temperamental weather conditions.

In hindsight, the choice of late October / early November and the Hallowe'en season seems natural enough. Oursler's psychologically-charged installation, although temporary in nature, nevertheless reached into new territory for a public presentation in the city. In New York, we are especially indebted to Target Stores, who underwrote the project as the first in the Public Art Fund's Target Art in the Park series; the City Parks Foundation and the NYC Department of Parks and Recreation, who oversee Madison Square Park; and those businesses and citizens around the park who, through a leap of faith, wholeheartedly endorsed this project during the restoration of this landmark neighborhood. The presentation in Soho Square was the last in a sequence of commissioning collaborations between Artangel and Beck's, and we're grateful for the committed support of Maurice Breen and Anthony Fawcett. Further support for the presentation in London came from the City of Westminster, the Stanley Thomas Johnson Foundation, the Henry Moore Foundation, the Calouste Gulbenkian Foundation and the private patronage of The Company of Angels, with the special help of Tom Bendhem and Anita and Poju Zabludowicz. And of course the many companies who, based around Soho Square, were most helpful and supportive. Without this support on both sides of the Atlantic it wouldn't have been possible for Tony Oursler to step out of the box and into the dark.

knock dot knock dash weak wire wande
Zap receiving mechanism make a dark n
girl makes a knocking sound Listen: -.
Killer "Kwaker" Killer "Kwaker" Knock
the Unseen to those in the Seen stati
dizzy open atmosphere little voice wa
away wire wonders: What has God wrou
anybody out there? Kate Fox? stop t
ping (knock knock) yes (knock) no: Hea
Mr. Split-foot can you count to ten?
are dead? the dead? the living? how

gnetic codes live like a spider along

finger moves fast the frogs leg jurks

• •• • •• • • •• • • •• • •• • •• • •• "k

ock who's there? Truths revealed by t

ipping surge currents cables consciou

ing lost and alone tap tap rap rap fr

Dot Knock Bang Dash Boom HELLO? HE

oice listen lines quickly crossed viol

Mr. Split-foot... do as I do (clap cl

old are you? How many are alive? Ho

ou separate the two? NOW HERE THIS:

SMOKE AND MIRRORS:

TONY OURSLER'S INFLUENCE MACHINE

A CONVERSATION BETWEEN

TONY OURSLER AND LOUISE NERI

Louise Neri: A few years ago, you embarked on two ambitious projects simultaneously: *Timestreams*, a mapping of the origins of technological imagination and its discoveries, which was realized as a project for the web (www.moma.org/timestream). And *The Influence Machine*, an outdoor *son-et-lumière* which was presented in New York's Madison Square Park and London's Soho Square last Fall. How did they both come about and how have they informed each other?

Tony Oursler: I compiled a timeline entitled *I hate the dark, I love the light* for my Williams College retrospective in 1998 because I was fascinated by how technologies like electric light, film, optics, radio, and the codification of the rainbow interrelated over time. I found myself being lured back into the historical labyrinth by a number of interests – the invention of television in particular – and then I had to keep investigating. My general theme was mimetic technology, that is, technology that could be perceived as a direct extension of psychological states.

LN: What do you mean by "mimetic technology"?

TO: I borrowed the term "mimetic" from pharmacology, where it is used to describe that class of drugs which mimics psychological states or provokes heightened states of consciousness. In the same way, or perhaps even more effectively, technology creates a dream space that mimics reality.

LN: So how did this lead to the idea of *son-et-lumière*?

TO: After our initial discussions about a public commission, which rekindled my interest in the public spectacle of *son-et-lumière*, I began a long period of pre-production research, during which information revealed itself serendipitously, interconnecting across time. Out of this process categories and historical figures emerged. On one of my first trips to London in connection with the commission, I was introduced to the work of Etienne-Gaspard Robertson, the eighteenth-century inventor of the *phantasmagoria*, through the writer Marina Warner.

Robertson's spectacles, in which he used magic lanterns and smoke projections, were the earliest instances of moving-image theater, staged in a crypt in Paris.

LN: How did Robertson become a pivotal source for you?

TO: Apart from Robertson's *phantasmagoria*, which I saw reconstructed at the Museum of the Moving Image in London, I read his autobiography, parts of which he wrote in a kind of dialogue with previous masters of optics, Alhazen (10th century) and Kircher (17th century). The autobiography also revealed his enduring obsession with the devil. He recounts that after failed attempts in his youth to conjure Satan himself, he invented certain special effects by which to make images of him instead. So there was a major paradigm shift from religion to entertainment. Hundreds of years later, Robertson inspired me to restructure my own timeline in a more subjective manner, based on darkness and light. And the sound-track for *The Influence Machine* which was written and produced by Tony Conrad, included a score for glass harmonica, a haunting Gothic instrument which was a favorite of Robertson's.

LN: How does your timeline differ from others?

TO: I tried to connect things that are not usually associated with each other. By necessity, the histories of Science and Art tend to specialize and focus on specific ideas to the exclusion of the big picture. Take, for example, the *camera obscura*: traditionally art history has treated it as a mere aid to perspective and drawing. But, more importantly, it was the first cultural production of virtual space installation, and the precursor to the mediated world of photography, film, and surveillance technologies. Since those categories are now part of art history, it's important that they be integrated into the central narrative. As a media artist, I wanted to make my own version of cultural history which incorporated these new mediums and technologies. Remember that it is only recently, in the last thirty years or so, that the moving image has been accepted into art history.

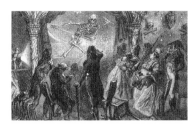

Robertson's *Phantasmagoria*

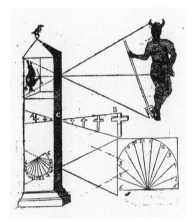

Althanasius Kircher's parastatic machine,
engraving for *Ars magna lucis et umbrae*, 1646

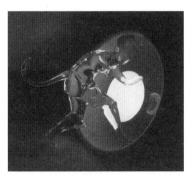

Tony Oursler, *Glass Devil*, 1999

LN: Why did this history become so important for you?

TO: I have always been interested in both the origins of media and "deep media structures" – meaning how people interact psychologically with technological media – as the basis for my own installations. I had also studied the development of special effects through the histories of theater, film and video and eventually taught this in art schools. But historical research was a new proposition for me. I like to keep the viewer in the vernacular, the here and now: sitting in a movie theater, or watching TV, or looking at a streetlight. So the challenge was to extend certain characters and events of the timeline into the present, and to link the viewer's current practices to other times. Each of the works that I produced from the timeline up to and including *The Influence Machine – Skulls and Still Lives, Empty Cabinet, The Darkest Color Infinitely Amplified, Through the Hole, Blue Transmission* – were in dialogue both with history and with contemporary social situations.

LN: Was it this that prompted you to transform the timeline into a web-site?

TO: I was invited to develop a web-site for The Museum of Modern Art, which seemed like a natural extension of the timeline I had begun for the Williams College retrospective. I was excited by the idea that a web-site makes the material available to people in different ways. I expanded the original material by about one third; most of the new entries were to do with contemporary technology; electronics, computers, Internet, and finally, all the psychic material. In transforming and expanding the timeline into the web-site *Timestreams*, I was able to crystallize how technological breakthroughs occurred, how they then entered the public domain, and the apparent psychological affect.

LN: What is it in particular that fascinates you about these moments of technological breakthrough?

TO: I fell in love with the epiphanies of technical invention and their narratives. I tried to strip them down to their bare facts, leaving the reader to embellish them. Take Faraday, who discovered photoconductivity, the ability of light to regulate the electrical conductivity of metal: Faraday was working at his desk one day and perceived an electrical cable being struck by sunlight; he noticed a voltage fluctuation. It was, literally, an epiphany, an illuminating moment. The importance of this moment was far-reaching. The reader might surmise how this moment evolved into numerous applications in the public sphere including the fax machine and television, where pictures are divided into blocks of light and dark signals, which are then sent along a wire to be decoded or reassembled in another location.

LN: What is also striking about many of these discoveries is their "improvisational" quality, their paradoxically "lo-tech" nature.

TO: Yes, it's always amazing to me how simple they were, that is, before the advent of electronics. But then it all starts getting very complicated. The last part of *Timestreams* was difficult because of this fact, whereas the early part was all about optics and alchemy, most of it beautifully simple. Some of these early methods and mechanisms remain unsurpassed, like the *camera obscura* which is pure and simple mimetic technology, a hole through which light passes, rendering an exact mirror of what exists in reality. We don't even really know how long ago the *camera obscura* was invented, although it is thought to be by the Chinese in the fifth century B.C.

LN: Are you making an analogy with the artistic process?

TO: Right up until Thomas Edison, these investigations and discoveries were more or less the personal and private experiences of technological inventors. Philosophers, tinkerers, scientists, amateurs and professionals alike, were individual, sometimes hermetic, players in the technological timeline. Edison was one of the first inventors to work in a workshop-like laboratory, which heralded the shift of technological investigation into a more corporate

context, where inventors became purveyors of ideas to the popular realm rather than solitary artists. Edison hired other scientists to work on his ideas; he worked to perfect existing ideas, and regularly visited the patent office to keep abreast of new developments.

LN: You've spoken about the literal aspects of technological development, but where does the issue of affect that you mentioned earlier come into it?

TO: During my research, I discovered a different narrative lurking in the shadows. It started with spirit photography and had to do with using technology to communicate with the dead. In 1844, Samuel Morse invented Morse code, enabling people to communicate instantly over long distances (Interestingly, he invoked God's role in the invention of the first message!) A few years later, a teenage girl called Kate Fox in Rochester, New York began communicating with the spirit of a murdered peddler by rapping on the walls of her house, using her own crude alphanumerical system, a kind of "folk" appropriation of Morse code. Her psychic activities caused a sensation parallel to the telegraph, sparking the New American Spiritualist Movement, which is still in existence today. This relation between psychic communication and telecommunications runs through each successive invention – the radio, the television, and finally, the computer.

LN: So how did all this relate to *The Influence Machine*?

TO: *The Influence Machine* took the advent of telecommunications as its point of departure and attempted to work with its discoveries in relation to the "deep media structures" I mentioned earlier. I'll give you an example: in physics we know that knocking is caused by energy transfer from hand to medium; a transformation from vibration to sound, from flesh to thought. This is a rudimentary technological transfer of waves of information, of life, "through mediums."

LN: Deer, for example, communicate to each other through the earth by stamping their hooves, whales

by emitting sonic messages through water... and so on. Echo was a mythic personification of early technology... what you are describing was represented literally in *The Influence Machine* as a huge projection of a fist knocking on an invisible surface...

TO: I came across this connection between the telegraph and psychic communication in a book by Jeffrey Sconce entitled *Haunted Media*. Morse code was the first thing that connected distant cities in real time and the fact that this moment in 1844 was the beginning of the telecommunications network we have today makes it one of the powerful moments in the history of the world. Imagine, when suddenly people could "talk" to each other in real time in another city, or travel by air, or were confronted with many electric inventions. Human consciousness expanded exponentially with these technological possibilities and, with this, humans became extremely susceptible anything seemed possible. Even scientists like Edison believed that there could be a machine to communicate with the dead. (He even made a wonderful film called *A Visit to the Spiritualist*!) If you suspend your disbelief for a moment, you will understand that the most powerful influence of all was the fact that people wanted to believe that all these things could be possible. And that belief persists today. I was able to track down groups on the Internet who practice communications through the computer, or the wonderful group in Luxembourg who have set up a television studio to broadcast and receive signals from the spirit world, using video feedback as a way of capturing these supernatural signals!

LN: So are you saying that "deep media structures" contribute to the mechanisms and functions of human belief in greater powers?

TO: Well, I am investigating how and why throughout history these discoveries become culturally symbolic; whether they themselves create new systems of belief.

LN: Can you elaborate?

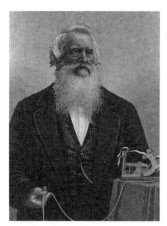

Samuel Morse

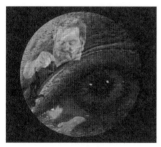

Tony Oursler, *The Darkest Color Infinitely Amplified*, 2001

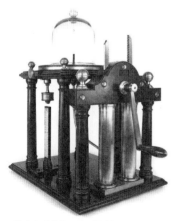

Hauksbee's Influencing Machine

TO: I wanted the timeline to be open-ended, so that others could use it as a tool. It had to be historically accurate. But, as the material came together, I started to see patterns which emphasized the ruling moral dichotomy of good and evil, expressed as darkness and light with various subplots. This added a new dynamic to the dry, historical facts and it seemed a natural way for me to organize material. The devil has worked his way into a number of my projects over the years, so I was interested in the connection to the Gothic and to technology. The devil, as the ultimate personification of evil, undergoes an elaborate transformation over time, from the theocratic world to the fragmented, secular world. He moves away from religion into magic and entertainment and, finally, cyberspace. This shift is most clearly laid out in my work *The Darkest Color Infinitely Amplified*.

LN: So where did the ideas for *The Influence Machine* come from?

TO: I've always been attracted to luminescence and colour. During one of my research trips to London, I came across documentation of Hauksbee's eighteenth-century invention, the Influencing Machine, a spherical glass vacuum that spun on its axis and emitted a greenish glow when rubbed, which was known as "the glow of life." In other words, a static electrical charge is introduced to a vacuum. At the time of its invention, the Influencing Machine had no scientific relevance. It was a useless yet strangely potent piece of equipment which became a kind of pseudo-scientific novelty or cipher used in sideshows and ascribed various talismanic powers, like a crystal ball. It is an example of another timeline theme: Quackery. (I am not using the term in a derogatory way, but rather as a tribute to these moments of oddly powerful human creativity.)

Then there was another strange coincidence. British historian Mark Cousins brought to my attention the work of Victor Tausk, one of Freud's students, who wrote an obscure but compelling text with the same title *The Influencing Machine*. He never refers to the historic machine but rather defines a psychological malady which he had observed in patients, a feeling that they were being controlled by a machine resembling a body but made of wildly complex electrical and mechanical parts.

LN: So what was its larger significance in your project?

TO: Arguably, the Influencing Machine was the first television set. It used the same basic technology, the glowing vacuum tube, and it had a similar mesmerising effect on its audience. From this simple technology developed hundreds of inventions including the cathode ray tube, the x-ray and the television. So it allowed me to link historical figures, such as John Baird, the British inventor of the mechanical television. Another extraordinary coincidence was that Soho Square, the site for *The Influence Machine* in London, is a stone's throw away from Baird's original Frith Street laboratory.

LN: It seems that people became susceptible to the Influencing Machine precisely because its powers were so abstract and unspecified. It was like a blank screen with many "points of entry" for self-realization.

You present your work as a "field" to be occupied, moved through at will. There is no single point of view. Likewise, with *The Influence Machine*, you transformed the classic form of the *son-et-lumière* – which usually takes place before a seated audience in linear dramaturgy – into an environment of different projected events occurring simultaneously. You combined the presence of electronic technology with the technology and collective energy of theater... it reminds me that when we were investigating sites for the work a couple of years ago, you actually considered an open air theater in London's Regent's Park.

TO: *The Influence Machine* is theatrical but, ultimately, I realized that I wanted to keep it in the context of art rather than theater, to present it as an installation, a visual and experiential "state" rather than a narrative.

A park was a perfect place for it, where the viewer was

able to wander through and around an environment rather than being presented with a fixed perspective. I gave a lot of thought to the way that the viewer moved in space, in some cases intercepting the light and smoke sources, which instantly and directly affected the forms of the projections themselves.

LN: So rather than working with the fixed spectacle of the medium, you were finding ways of visibly breaking it down into all the various elements that constituted it.

TO: Yes, it moved back and forth in time, ultimately collapsing in the mix. That is also what was important about staging the work outside, in direct relation to a city, rather than containing it in an interior space. Everything dispersed in open space – the sound, the smoke, the light, the viewers. The installation fused with the larger mechanism of the city – the ambient light and sound, the traffic, the streetlights, the weather. The outside poured into the piece, the piece poured out into the city.

LN: This process of dispersing, channeling, pooling was something of a breakthrough in your work. In doing so, you managed to infuse specific locales with the idea of a bigger "beyond," both sonically and visually, through the history you were drawing on and the broad range of people you brought into the creative process and the work itself – the chorus, the medium, the talking street light.

TO: It was a big departure for me to make artworks as various kinds of channeling devices. For the talking light, a web-site was set up to which people could write. Their texts were transcribed daily onto a CD and then broadcast in the park each evening. It was something like Speaker's Corner in Hyde Park in London except the speakers were disembodied; their "voices" came from the Internet and were broadcast through a synchronized streetlight.

LN: What were the texts like?

TO: Declarations of love, imperatives, hellos, laments.

Some kids typed in their messages then came to the pa to hear it broadcast.

LN: What about your own scripting for the installation?

TO: In the process of culling the various events from the timeline for *The Influence Machine*, I had to think about how to give voice to their central characters. I wanted d ferent voices, different vessels for my text to run throug Tony Conrad and I visited the famous psychic commun in Lily Dale – which was, incidentally, where the house of Kate Fox was eventually moved to. There I observed and taped professional psychics, how they channeled the spirits of the so-called dead. It was a pretty profoun experience.

LN: So how did this experience affect your actual writing style? You once described to me how you usually write your scripts, with several audio sources turned on at the same time so that you can channel and mix the informa tion as it is broadcast, resulting in a form resembling stream-of-consciousness. Was it very different this time

TO: Yes. My writing tends to be rather opaque. In this instance, because there was so much historical informa tion and it was a public situation, I felt I had to be very clear in order to communicate specific meanings. I edite much more than usual. The performers were more varie I wanted a social cross-section and when I cast the characters, I rewrote the scripts specifically for them. Ultimately, I knew that most people would only spend a few minutes in the park watching, but if they wanted to go further into the material it was all there. That's how it was written.

LN: Can you describe the installation itself?

TO: There were five parts to the installation: "Mediums, "Chorus," "The Technician," text messages, "Talking Street Light" and, finally, "Knocking / Spirit Voices." Each had a different sort of script.

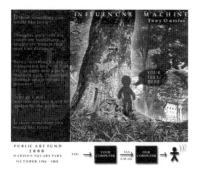

The Influence Machine web-site

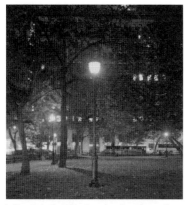

In New York, *The Talking Lamp* broadcast the emails submitted to *The Influence Machine* web-site

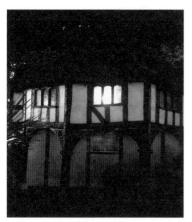

In London, *The Talking Light* broadcast the emails submitted to *The Influence Machine* web-site

In the Medium work, in which apparitions of historical characters appeared projected onto smoke, I used very simple transitions, introducing each character – "Coming to you from 1932, this is Baird," and so on – because I realized that if the script was too obscure, the content would be lost. I combined my own original writing with first-person quotations, drawn from first-person accounts, such as Robertson, Baird, and Tauske. They spoke through two characters played by Sidney Lawrence and Tracy Leipold, mixing together in a sort of conversation as their images drifted in the smoke.

LN: Conversation or, rather, séance... In French, séance also means a cinema-screening, so the relation between spirits, technology and screen memory is implicit. Jeffrey Sconce discusses the equivalences between technological and human bodies, for example the flow of electricity versus the flow of human consciousness, the human fascination with the "living" quality and live presence of popular technologies.

TO: Technologies attach themselves to the interface between our conscious and unconscious states so, in a sense, they are alive. Or at least, they seem to be. That's the confusing thing. If we can be sufficiently convinced to think that we experience media in the same way that we see reality, then it will not be an issue – A.I. (artificial intelligence) or not – the blurring effect will be the same, which opens us up to the possibility of mind control in entirely new areas. The anthropomorphising of media is very natural: the soundtrack for "Knocking" incorporates found "spirit voices" from various ghost-hunting sites on the Internet. These sounds are like audio-Rorschach tests recorded from "dead" channels, the white noise of radio and TV.

LN: What do you mean when you describe media as "natural"?

TO: When I was a child I believed that what went on on television was real. Now I see kids talking to my installations. I am interested in what this innate human desire for mimetics is, why we like sitting in dark rooms, in front of screens, absorbing programmed material, rather than actually participating in the contingencies and textures of life.

LN: Long ago, theorists and writers speculated that media interface would increasingly come to substitute "real" social connection. That time is now. In addition, "Reality TV" has become more and more popular, perceived "real" situations that people can empathize with and obsess about. Timothy McVeigh was executed while the families of his victims watched on closed-circuit TV. This touches the other realm that you are dealing with in your work – technological control and psychosis.

TO: In *Timestreams* there is an entry from 1975 claiming that by the time the average kid finishes high school, s/he will have spent almost twice the time spent at school watching television, approximately 20,000 hours. And that was before the advent of personal computers. I read more recently that in this same period today, the same high schooler will have "witnessed" 16,000 violent deaths on television. These facts suggest larger issues about human susceptibility and the drift away from one reality to another. The mimetic world of violence finds the weakest link in this psychological chain and activates it.

LN: Reality is harder and harder to locate because of this so-called mimetic technology. Because I disagree with you that it is truly mimetic; it's not a mirror image of reality like the *camera obscura*; rather it reflects a modified reality that is rendered comprehensible along certain lines that we may or may not be aware of as viewers.

TO: Sometimes I think a machine could be made that would have perceived intelligence. One could construct a very "intelligent" machine by tailoring it to the basic parameters of human need. That speaks to the whole code of why movies and TV work so well. There are a limited number of things that most people want to see. So the ability to control comes down to simply perceiving behavioral frameworks. Mapping out what people like to

do allows the machine to occupy people's minds. The machine takes on an almost sentient quality although it is completely stupid and inert at the same time, like the new electronic animals for kids.

LN: So where does your work stand in relation to this discussion? Obviously you embrace the seductive powers of technology, yet your work often appears as being "flawed," overfilled and confusing and irrational. You tend to work things until they barely hold together. This idea of breakdown and dispersal functions as being anti-authoritative, anti-persuasive. You expose the mechanisms and the relations in your work – like the talking heads that are barely audible, or the characters that all talk at once. The power of the image is all but cancelled out across a common zone of activity because all the images compete for the same (human) attention, which is both maddening and mesmerising...

TO: Some are very clear and focused; you can hear every word. Other works play with overlapping texts and levels of auditory hallucination; they invite the viewer's collaboration. Traditional art forms contain less information on a certain level and thus encourage people to fill the space with their own readings. The brain is an organic thing, identity is always in flux, cognition is changing all the time, thus a static artwork takes this into account and has a longer life than a film in some ways. Less information equals more power as it reflects the changes of the viewer more clearly. "The Technician," from *The Influence Machine* which is projected scrolling text is based on a typed conversation I found between a person on a computer and a spirit which was typing back from the "spirit side." I love the creativity, the engagement, the human instinct implied.

The problem with media is that it occupies so many senses at one time that it can tend to cancel itself out. I always hope that the viewer will find his own position with regard to my work, rather than just being persuaded by it. That is really the subliminal theme of *The Influence Machine*, how we can grasp the corporate mechanism and use it for our own individual ends.

LN: You have been accused of being repetitive and relying on spectacle, but I think that is a superficial response to the work. Each one of the talking heads has a different script, exploring different ideas and themes. Those pieces give the viewer the impression of entertaining, of occupying that passive space in the dark which the viewer of technology occupies so readily. But I would argue that there is a whole other layer of activity that exists in your work which often gets passed over.

TO: With *The Influence Machine*, I wanted people to have this experience in the park so that the information would reach them in a state of active deconstruction, so that the technological "miracle" would be rendered transparent. I wanted to present it as an inquiry into why we human moths are so mesmerised by the technological flame, as opposed to other active human options.

The art world is growing exponentially and I think the reason is that art imparts a different experience than media. In art, people are part of the process in that their critical faculties are activated. It's not like being moved through a Spielbergian maze.

LN: Or a seamless, logical narrative with a beginning, a middle and an end.

TO: No, yet I am convinced that the narrative impulse is so innate to human nature that no matter how chaotic the information, people can make their own story from the information they are given, ascribe it meaning. I think it's important to invigorate that aspect of human perception. That is why we go and look at art, as an experience that respects our integrity as participants.

New York City, May–August 2001

the noise the noise the noise the no ugh) is killing me... mommy mommy I'm re don't leave me "Hey stop talking rough the lady", I've got to go... ge mething to eat wait Time... Time give me ha ha ha I'm hungry aaahhhh yyy- esss let me introduce you to... "Mr. ... "Mr. X"... I'll be who ever you w to be mutated materialization Farnsw ird Robertson all mixed up slicing suc ak up smoke image dissector YOU agai

THE PATHOLOGY OF PROJECTIONS

AND CYNICAL SPIRITUALISM

BY CARLO McCORMICK

Shamans and priests, doctors and healers, scientists and seers, alchemists and astronauts, artists and tricksters all: each with their different agendas, all after the same old riddles, conjuring the unknowable as manifest with the consensual authority, chicanery and conceit of their esoteric crafts. For this post-evolutionary ape's first proto-cultural gestures, be it looking to the skies for the face of god or painting in the caves to visualize the magic of a successful hunt, the need for answers is of the same root as our capacity to make up our truths as we go along. And when you're wielding generalities, speculations, superstitions, and methodologies that are at best myopically reductionist, as the validating proof of some trans-substantial cosmological certainty, well, you best have some skills in the sleight of hand and work in gestures that are grander than the practicalities of life itself.

We are by nature a rather skeptical species. Yet, of all God's creatures we are certainly the only ones who across all cultures have believed in an invisible, absolutely irra-tional, supernatural, spiritualist dimension. Tony Oursler, one of those rare exceptions who seemingly has not been wired to make such leaps of faith, is hardly a believer. And his art is not really concerned with God or gods per se. Most likely such deep theological issues would be a little too silly for him. What Oursler's The Influence Machine is more about, is the curious, seemingly inexplicable, aspect of the mind to invent these metaphysical forces, and to believe in them. The art in this for Oursler is not some divine spirit, but the very human capacity to project these images into the ether, void of existence, in such a way that they suddenly become apparent.

Lest the very idea of talking to such an unrepentant athe-ist as Tony Oursler about spirituality in his art seems the visual equivalent of looking for the face of Elvis in a moldy piece of bread, consider that he was born Fulton Oursler III. That would make his grandfather, Fulton Sr., the author of The Greatest Story Ever Told, a broad popularization of The Bible (if ever there was an oxymoron), that became an enduring best-seller in America. Fulton Sr., a long-time editor for the likes of Liberty Magazine, and the very suc-

cessful True Crime, a magazine which he co-founded, authored some hundred-plus books in his lifetime, but it was his Greatest Story that proved to be his greatest suc-cess, a biblical epic of such proportions that Hollywood itself could not resist turning it into one of the most successful stories of the life of Jesus ever to hit the big screen. The movie version, directed by George Stevens, arrived in 1965 with a star studded cast including Max Von Sydow, Telly Savalas, Dorothy McGuire, Charlton Heston, Jose Ferrer, Claude Raines and Van Heflin. Big budget and monumental, at some 225 minutes long, the pompous spectacle remained for many generations the closest most Americans ever got to actually knowing the Bible. And then Junior, Tony's dad, after a long career as editor and vice president of the immensely popular maga-zine Reader's Digest, went on to be the founding editor of Angels on Earth, where every month readers were regaled with "true stories" of divine intervention and the kind of blessings that come with faith. Still being published and widely read today, Angels on Earth offers up stories based in faith through angelic intervention, stories in which the celestial spiritual bodies literally would come down to our material world to guide and assist those in great need.

This abiding sense of faith, at once so abstracted in Tony's own work, is to his creative process "an inherited mantra – guardian angels and devils – almost like a men-tal illness." In as much as Tony Oursler's vision is honed by scrutiny and doubt – his lens a kind of super-acute analytic tool – his long-standing fascination with the psy-chological topographies of image, form and narrative must intuitively stem from this familial and greater social dementia of belief. Like some prodigal child who has deliberately thrown out the transcendental map that had been passed down in his family for generations, Oursler has danced in self-imposed exile around the proverbial garden – always on the outside, but still looking in, forever staying away, but never too far from the cloying embrace of religion's comforting and complacent home. "It's intense," Oursler admits, "you can't get rid of it."

The legacy here is certainly much more than an aesthet-

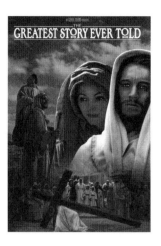

armature of denial. To enjoy how that which "you can't get rid of" plays out in Tony Oursler's early single-channel video work, consider how his hilariously amateur puppet shows relate to the crude programming of old Christian television children's shows. Think of *Davey and Goliath*, a claymation cartoon that doubled as Bible-story lessons, which ran throughout America as early morning children's television programming, or for the great aficionados of pop oddity, try out the obscure treasure of Ventriloquist Children's TV shows, à la *Jimmy and Rusty*, or *Marcy*, and countless others that had their heyday in the early to mid-Seventies on local affiliates and regional stations as a truly perverse form of Bible story-lessons, featuring some ventriloquist (usually a woman) with a dummy child on her knee, explaining the parables and moral truths of the good book. For Oursler, this kind of absurdity takes on greater relevance in the light of the fact that the first television broadcast was of a ventriloquist.

Oursler still has his fun, but in his mature work produced since the mid-Eighties, his jaded punk sarcasms of yore have been replaced by greater complexities of information manipulated through ever more baroque fantasy structures and paranoid delusions. Kind of like the evolution of most religions, you may be thinking. It is certainly these fantasy structures, socially inherited or physiologically inherent, that fascinate Oursler, and provide the strongest link between his œuvre and the outstanding dominant body of contemporary spiritual practice. Growing up Catholic, or as he describes it, "believing in a system that's not there," what Oursler learned from a family of church-based storytellers is a particular kind of inflection, a way of conjuring disembodied forms and fleshing out the immaterial. In such a way, we can see these same kinds of spiritual parable strategies employed by Oursler in his most renowned body of sculptural work, when he projects actual human faces on rag dolls – making us see what's literally not there in a humbuggeried suspension of disbelief. These are narrative devices and representational strategies he uses, not simply because they make good art (hell, in a world where "a sucker is born every minute," they are the essence of show biz itself), but because they

are at the heart of contradictions around which all his pictorial issues revolve. Tony Oursler as an apparent heir to the new genres of Seventies art, is concerned with process more than product, and when he tricks us into seeing things that aren't there, or pushes our emotional buttons, he's not doing it to manipulate us so much as to help us understand the formal ways in which these kinds of manipulations can occur.

Premiered in New York during America's anachronistic pagan holiday of Hallowe'en – a sort of hyper-commercialized celebration of the dead replete with witches, skeletons and all manner of cartoonish morbidity – and in London in the waning days of Fall into Winter, itself a seasonal metaphor for life's mortal transience, Oursler's *The Influence Machine* was in every way a public haunting. The artist here is himself going further than creating an elaborate multi-media spook house (though it does clearly enjoy some of those elements), he's revisiting the ways in which such apparitions act as ephemeral transmissions between the frailty of existence and the vast unknown of death. For believers and non-believers alike, the notion of life after death cannot help but have an irresistible appeal. For Oursler, whose art and ideas maintain a brutal existentialism (not to be confused here with nihilism, which is far too depressing and negative for Oursler, who prefers to regard all this with a greater sense of humor and pleasure), the fashions by which we collectively imagine some continuance after this brief futile dance upon Earth are perhaps an even greater mystery than life itself. Even with the modest comforts of secular humanism, the position that Oursler is willing to accept, a here-today-gone-tomorrow, worm-food spiritless biological absolute, is mighty hard to take, as is, without compromise. Don't we all need some sort of construct of ulterior being, a grand master-plan to give sense and solution to why we are here in the first place? Every culture across all times and environments has imagined its own vision of guiding forces and constructed its elaborate rituals for death and burial. As different as all religions may be, in the end, doesn't their existence in every isolated facet of human consciousness or corner of this planet tell us that

we all need this embrace to keep our very sense of self in the harsh cold of always immanent demise? By not particularly buying into this shared yet, differentiated universal language of immortality, Tony Oursler it would seem must take his own curious comfort in enjoying the absurdities of how this psychological need has become a mutant set of undead signifiers for a culture at the end of history. He relishes in the particulars, but it is the phenomenology of our self-deceit as a whole that fascinates him and informs his art.

The Influence Machine, a multi-projection, mock environment of ghostly apparitions is a glorious celebration of the huckster spectacle. However, unlike most who parlay in eerie trickery, Oursler gladly parts that red velvet curtain to reveal the modest means behind the mighty Oz. Rooted in the primary gestures of performance art, Oursler minds neither those aspects of self-referentiality nor process as visible, quotable elements of a new media formalism. Essential to this development in Oursler's installation work is his ongoing construction of an evermore elaborate timeline, in which he has been carefully plotting the trajectory of such illusory projections. He enjoys phenomena in and of itself, but what he is really after is a larger map of the phenomenology as a holographic model of human desire and dread. In relation to the Christian texts of his paternal branch, he draws a comparison between religion and art in how both "think about things that aren't there and make them concrete, using an associative quality that's super poetic to read objects in multiple ways."

Thus, as the iconography of the church allows us to read the divine or the devil in all manner of objects from the material world, be it gems, stained glass, vanitas, memento mori or even dogwood trees (from many of which this artist has borrowed imagery and ways of seeing things in his earlier pieces), Oursler can follow this kind of medieval symbolism as metaphysical allegory with the awareness that this still happens today in both art and religion. For this artist – be it the way in which Abbé Suger found the face of God in gems and stained glass,

or how American folkloric Biblisms have it that since the wood used to crucify Christ was from a dogwood tree you can see in its flowers both the nail hole and the blood, and in its stunted growth the curse that this tree will never grow to a size capable of supplying another crucifixion – it is "the wonderful paranoia in how they read all this symbolism" that informs his manic layering of visual information and symbolic meaning. The multiple meanings that Oursler invests in The Influence Machine then are spawned from his investigations in what he calls "magical thinking," an aspect of consciousness he is concerned with less for its capacity for magic than its basic transmission of social and individual psychology.

Drawing extensively from his obsessively researched timeline, Tony Oursler will freely employ the strategies all that abracadabra, now-you-see-it-now-you-don't, smoke and mirrors prestidigitation, of proto-cinematic projections, as an investigation into the arcane roots of his supposedly new medium and an intervention into the mysticist causes for all these extraordinary effects. From Gaspar Robertson's moving image theater of the 1790s conjuring the devil in a Parisian crypt, to Kircher's camera obscura, running parallel yet divergent to its age of Enlightenment, Oursler takes those shadows out of Plato's Cave and does the whole phantasmagorical light show of evolving technology's increasingly more sophisticated projections. And more than simply the quasi-scientific charlatan's way of conjuring the worlds beyond, the way in which Oursler distills this technology is in itself life after death, a mode of reproduction in the simulacra of living on through what has been made, that is at the heart of The Influence Machine. Technology is its own post-human Golem here, not so much the persistence of spirit as the interminable machine. Be it all the ways that technology cheats death, from perpetual simulation to more simply scaring the begeesus out of people, the way in which television's constant reminder/rebroadcast of death acts to invoke some personal victory over it (this time) for the viewer, or the immediate, nearly concurrent rise of spirit photography that accompanied the birth of this seminal medium of mechanical reproduction – Ours

understands how the mystery of every technological inno-
vation has brought with it a deeply superstitious sense
of possibility in terms of communicating with the dead.
It is a rapping, a communication with loved ones no
more, a bridge between life and death. It is a hoax, a loss
and its need is so great that it would have to bear its own
witness. It is a dimmed light, a thrown voice, a disem-
bodied sound, a rising table or a mysteriously scrawled
message. It is *The Influence Machine* – the casting of
spells, the mesmeric hypnosis of a more than willing
subject, the suspension of disbelief we all make every
time the lights dim and the film starts to roll. It is the
projects, personal and cultural, we all make when we face
the dark unknown. In the end, perhaps, it's not really that
Tony Oursler does not believe in God, it's more like he
believes so dearly in the power of the mind, the spirit of
invention, the psychology of imagination and the stub-
born will of faith, that he would rather attribute this tran-
scendental power to humanity itself than the inevitably
flawed fantasies of our own myopic cosmologies.

my dreams are your command stop flow

good I'm negative I'm positive. In and

scene OH NO there goes my body again

fear of death there is no death, body

the big deal death do it to me death

swarm of energy feedback system I am

to you: It's the same here as it is th

tality the human personality and its s

tion after we die what then? I'm canc

to Communications gone I'm gone far o

you you catch me caught inside, insid

…es out of me me me look at me oh th…

…; and back to me all the possibilities …

…of! gone stop start poof! here we go …

…th? I am your perfect match no death …

… blue eye good now the spirit organs …

…t ever you want me to be. I hate to b…

…it never ends problems solved unsolv…

…val after body death let's dream it u…

… out Electromagnetic Etheric Systems …

… bring me back to life please, I want …

…u, I can hide, let me hide, inside, I'…

'OURSELF BEHIND OURSELF, CONCEALED...': ETHEREAL WHISPERS FROM THE DARK SIDE BY MARINA WARNER

In the spring of 2001, an American scientist, in London for a conference, made a startling claim on the *Today* programme of the BBC: transplanted organs could transfer memories from one person to another. He knew a little girl who had received the heart of a murder victim, and was thereafter able to recall the circumstances of her donor's death. She had even identified the murderer. The programme's presenter was incredulous, and challenged the guest with all the considerable forensic skills he could muster. But the scientist stuck fast to his vision of transferred consciousness, which he called 'cellular memory'; he was standing by it, against the views of almost all transplant doctors and patients, none of whom have reported any such possibility. What was more revealing, however, was the interest in 'cellular memory' by a self-consciously balanced, highly esteemed serious programme; that this alternative thinker wasn't penned up in the pages of *Bizarre* or the *Fortean Times*, but was being given prime time. His appearance showed how deeply our ideas of person and self have altered since the unique, individual body-soul integrity that I for one was brought up to believe in my Catholic girlhood.

But 'cellular memory' is only one hypothesis, amongst many. Tony Oursler has long been fascinated by the proliferating versions of human consciousness, of its powers and connections. He's not offering a solution, let alone a dogma or orthodoxy; his muttering automata and dummies and dolls leave rather an eddying sense of indeterminacy, vagueness, mystery. His figures are animated, sometimes performed by single, existing individuals. But these 'effigies' – his preferred term – also act as technological transmitters/receivers/channelers. They're ventriloquised from a distance by other voices, other presences, through instruments that 'beam them up', media that belong to the richly varied panoply that human ingenuity has devised to probe the invisible, the inaudible, the intangible.

First the telescope, then the microscope, revealed unimaginable universes crowded and teeming with life in dimensions beyond the reach of the naked eye; the barometer registered impalpable changes in air pressure. But it wasn't until the invention of aural probes and wave detectors that the invisible air itself became a seething Babel, moving to a complex interplay of forces and signals. This is Oursler territory: beyond the spectacle and the scopic, vibrating to the hum of the imponderable powers that govern space time and our living presence within their constraints. The air began yielding up all manner of mysteries to the new diagnostic tools devised to detect and inventory its messages. These weren't making themselves manifest as mimic or figural images, representing something recognisable, but struck human consciousness as noise – at first unintelligible, then turning out to be coded in wave in photons, in pulses.[1] The music of the spheres was tuned rather differently than Pythagoras or Plato and their successors had imagined.

However, nineteenth and twentieth-century physical discoveries, for all their progressive and scientific character continued to be bent through the lens of metaphysics: existing languages of philosophical speculation provided the necessary ways to think about the edges of knowledge and the borderland where natural and supernatural meet. Through his curiosity about experiments in this field, Tony Oursler has developed a profound, original and imaginative relationship to its history and its processes. As his Time Line reveals, mesmeric theories were woven into concepts of electricity; similarly, the discovery of x-rays, facilitated by William Crookes's experiments with vacuums and established by Wilhelm Conrad Röntgen in 1895, the identification of radio waves and the subsequent invention of the wireless, of telegraphy, of the telephone, produced a fevered – and delighted – search to penetrate the unseen. Channels of communication through the ether, presented themselves in potentia as deliriously numberless; they became intertwined with the physical possibility of moving objects at a distance by finding some vehicle analogous to radio waves. It was in the 1890s, that the prefix tele-, used in so many optical and other probes, was also attached to telepathy, by the philosopher Frederic Myers, and to term coined by the Society for Psychical Research, of which he was a founder, such as tele-kinesis.[2]

It's difficult from our hooked up, www.com vantage poi

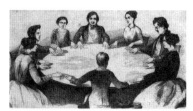

A 19th century séance featuring the Fox sisters' table rapping 'technique'

Katie Fox

The Fox House in Lily Dale, New York

today to imagine how exciting, fascinating, and extreme seemed the possibilities that these instruments opened up for their first users. The new media left the trace of their passage: indeed their activity became legible only through such traces. Radio waves could not be grasped by human senses: only the effects of the new methods of transmission, as the mark of a needle quivering on a drum as the taps came through, as the translated and disincarnate voices from the radio set. Visible verification surrendered its hegemony to other warranties of presence – sonic, and haptic.[3] Material impressions of the new media's work were in high demand. In the absence of external sensory means to verify the principle at work, a dependence on second-order technological proof of hidden energy arose, as in the photograph or the x-ray plate. The extension of the word 'medium' itself, in the early 1850s, to someone with paranormal powers, reveals the parallelism perceived between the vehicle – the ether – and its interpreters and their products. The new technologies offered a model for expression that was extended to phenomena as yet beyond the reach of scientific empiricism. When the first Spiritualist phenomena were reported, the revenants communicated in raps; it is unlikely to be coincidence that the early telegraph was using Morse code for its first messages. Wireless telegraphy was invented at the same time and inaugurated in Rochester near the home of the first psychic mediums, the Fox sisters. Early photographers captured the aura or etheric body of their subjects, or of their subjects' loved ones: the popularity of this form of psychic souvenir spreads with the gradual accessibility of the high street photographic parlour and the medium's rapidly burgeoning popularity. The ghostly quality of the image on the glass plate and the monochrome print lent itself to picturing spirit. William James put his finger on the similarity of the scientific and psychic experiments as perceived at the time, when he wrote that phenomena like automatic writing were 'instruments of research, reagents like litmus paper or the galvanometer for revealing what would otherwise be hidden.'[4] Tony Oursler is one of several contemporary artists who have annexed the latest instruments of global communications to explore the relationship between individual consciousness and the noise of the universe. His work consistently probes the convergence of physics and experiences of the psyche. As A.K. Coomaraswamy advocated so eloquently in his studies of the spiritual in art, aesthetics should not be regarded as a branch of sensation or feeling, but of thinking: making art means making a language, evolving a means of expression, a means of puzzling out ideas and deepening knowledge.[5] Artists today increasingly respond to the history of ideas, exploring forms of representation with awareness of their past uses, developing a critique as they press out new templates: Oursler is at one and the same time an ironic commentator on psychological theories and an adept of some of its weirdest and most wonderful propositions.

Nineteenth-century technologies added a new language of haunting and possession, even as they also contributed to unsettling notions of the integrated person. Tony Oursler for example took the idea of the 'influence machine' itself from a device which was invented in 1706 by a student of Isaac Newton called Francis Hauksbee; it consisted of a globe which spun, crackling and sparking as it did so. In turn, this machine inspired the title of a celebrated article by Victor Tausk, delivered in Vienna in 1918 to the Psychoanalytical Society, in which he discussed several patients who believed they were under the influence of some device or other, and suffered from hallucinations, locutions, a despairing sense of losing control of their own being: 'The schizophrenic influencing machine', writes Tausk, 'is a machine of mystical nature. The patients are able to give only vague hints of its construction. It consists of boxes, cranks, levers, wheels, buttons, wires, batteries, and the like... The main effects... are... It makes the patients see pictures. It produces, as well as removes, thoughts and feelings by means of waves or rays or mysterious forces... In such cases, the machine is often called a suggestion-apparatus. The machine serves to persecute the patient and is operated by enemies...'[6]

The cases Tausk described were among the first of their kind to be analysed; the paper is a classic of psychoanalytical literature, alongside Daniel Paul Schreber's *Memoirs of My Nervous Illness* (1903), in which a High Court judge in Germany recalled his mental agony, break-

downs and hospitalisation over a period of some twenty years at the turn of the century. Schreber's long, minutely detailed, perfect simulacrum of a calmly rational memory act was cited enthusiastically by Freud, Jung and, more recently, Gilles Deleuze, as the most remarkable personal testimony of derangement, and he too invokes waves and vibrations – the new manifestation of the physical universe – to describe his mental states: 'Apart from normal human language', he wrote, 'there is also a kind of nerve-language... that is to say a human being causes his nerves to vibrate... in my case, however... my nerves have been set in motion from without incessantly and without any respite.'[7]

The stories of patients whose work was seen recently in the travelling show of the Prinzhorn collection, also calls on new technologies – x-rays, radio, telegraphy – to account for experiences of double or triple personality, of voices (locutions, in the theological phrase) overheard that direct the sufferer, of possession and trance.[8] Beyond the boundaries of mental disturbance, in established religious practice, similar metaphors are also used to describe connections with inspiration and the divine: in Baptist ceremonies of *glossolalia*, otherwise known as speaking in tongues, for instance, God's messages come down the 'heavenly telephone'. But the question of madness on the one hand, or Spiritualist or other supernatural belief systems on the other does not arise within the boundaries set by Oursler's work, because it doesn't make claims to represent something that the artist has experienced exclusively, or to which he has some kind of special access: Oursler isn't claiming to be a magus. He's a child of the Seventies, of the television age, the same age as systems such as cable and satellite and the web. The polyphonic aural universe fascinates Oursler as deeply as visual signals. In his art, he listens in and collects evidence of the senses in the altered conditions of consciousness that now prevail.

In a statement about *The Influence Machine*, he observes: 'Telecommunication systems such as the Internet are the end-product of a long drive towards the current paradox of mind/body separation... This paradox of the dis-corporative impulse, the shedding of the physical body for the ethereal utopian virtual presence and the promises of ulti-

mate interconnectivity is at once linked to the fear of the void, isolation, and disassociative conditions... Today when the average person finds themselves increasingly engaged with mimetic systems, as they move from telephone to television to Internet, and back again, the metaphor of the uncanny technological equation between life and death is all the more relevant.'

Television, his art implies, has become the influencing machine on all our minds. It also sets the scene for a new afterlife, where the past meets the future and turns into an ever repeating, eternal present: 'Television archives store millions of images of the dead, which wait to be broadcast... to the living... at this point, the dead come back to life to have an influence... on the living... Television is, then, truly the spirit world of our age. It preserves images of the dead which then can continue to haunt us... it also gives us the phenomenon of living ghosts, or stars as we like to call them...'

* * *

Several writers who explore human character, starting in the Victorian era and continuing today, have proposed a form of personality which utterly breaks with the Judaeo-Christian compact of body and soul in the idea of the person and works instead with the idea that individuals can become possessed by some other being, or 'alter'. In Spiritualism, the 'gifted' individual not only becomes subject to a 'spirit control', but the spirit control might then itself mediate the ghosts of yet more people until a séance can become quite crowded.

A double – a self behind a self, concealed – haunts fantasy literature and fairy tales; its spectral presence moves eerily through several marvellous tales of E.T.A. Hoffmann and Edgar Allan Poe, and inhabits the large and various fiction of possession, from the prodigious frenzy of James Hogg novel of 1824, *Private Memoirs and Confessions of a Justified Sinner*, to the cult classic that inspired the film *Blade Runner*, *Do Androids Dream of Electric Sheep?* by Philip K. Dick. Since Hogg wrote his extraordinary study of religious fanaticism and derangement, figures of multiple identity, of shared and scattered personal memories, of zombie thefts of soul and spirit, of out-of-the-body wan-

derings and split existences have passed from the margins of literature through the main doors of the canon, inspiring plots in writers as diverse as R.L. Stevenson, Lewis Carroll (not only the *Alice* books, but the later, neglected two-volume *Sylvie and Bruno*). For example, Emily Dickinson, in a poem of around 1863, writes about confronting an uncanny alter ego; presciently, she locates this self, not in the exterior world of ghosts and spectres, but within: inside the mind, inside the self. This inner spectre lurks far more disturbingly, she writes, than the phantoms of church or graveyard:

One need not be a Chamber – to be Haunted –
One need not be a House –
The Brain has Corridors – surpassing
Material Place –
...
Far safer, through an Abbey gallop,
The Stones a'chase –
Than Unarmed, one's a'self encounter –
...
Ourself behind Ourself, concealed –
Should startle most –
...

Margaret Atwood quotes the poem as an epigraph to her compelling novel, *Alias Grace* (1997). Set against a Spiritualist background in Canada and the United States, it's the story of the most famous Canadian murderess, who was 16 in 1863 when she killed two people, and it proposes, highly convincingly, through the sheer narrative power of the writing, that she was actually led by the ghost of a dead friend to avenge her and commit the crimes. *Alias Grace*, with its doubling title, depends on belief in spirit possession and multiple personality seen through the lens of nineteenth-century psychology; Atwood places the birth of psychoanalysis clearly within the bounds of supernatural theories of mind.

The condition that has above all fascinated Tony Oursler is Multiple Personality Disorder, which was described in the case study of Helene Smith, made by Théodore Flournoy in Switzerland in 1900.[9] The resulting book is called *Des Indes au Planète Mars* as Helene enfolded within her, Flournoy recorded, the personae of an Indian Princess as well as a Martian leader: Helene could inhabit

her several identities with conviction: she could speak in a Martian tongue and made detailed drawings of the Martians' mode of travel: a spinning, hand-held fan somewhat like a child's windmill. Years later, the American psychologist described the case of another young woman who contained even more identities: it was he who gave the syndrome its name, Multiple Personality Disorder, and its symptoms have now been presented in numerous more cases as well, of course, as inspiring supernatural fictions, with the horror impresario Stephen King setting the pace.

Oursler is fascinated by MPD, not only as a clinical condition but as a state of consciousness, that might be available to anyone through trance, performance, and inspiration. Historically, the state of possession has not been diagnosed as mental illness: to call upon only one scene, for example, Virgil in the *Aeneid* passionately evokes the frenzy of the Sybil of Cumae, as the god takes possession of her and speaks through her in her echoing cave; the frenzy makes her rave and froth, but, for the Romans, doesn't define her as mad. Oursler has worked for some time with Tracy Leipold, who can produce different voices and excavate different personalities within herself, at will. Oursler both prompts, sustains and records her *glossolalia*. He wants to register and transmit the noise inside the brain and out: the crackling and sparking of consciousness, including the individual unconscious, as well as the messages of interstellar frequencies, with all the gibberish and distortions, interference and jumble that past models of self have screened out. His babble and mutterings turn to the imagery of computer communication to create a sound poem that take the venerable nonsense tradition in the direction of paranoid, psychological portraiture: 'you catch me like a virus from a sound from a bird from its voice through the air from a bug caught inside, inside you, I can hide, let me hide, inside, I'll be quiet. I'll be watching...'

This area of interest seems to be shedding its embarrassing undertones to take its place as part of the urgent need for the 're-enchantment of the world'. Amongst artists and writers today, this shift results, I feel, from the larger question with which they are engaged: who or what is a

person? The question is related to agency: who I am matters, affects, in more ways than one, what I make. And the converse: what I make matters with regard to who I am. The paradox of Duchamp's urinal, that the artist need only sign a work to make it art, raised the question of authorship in ways that challenge the death of the author, proclaimed nearly half a century later by Roland Barthes. Issues of authorship and its implied origin in authority require clarification of identity: it is not possible to copyright some act of making as all your own work – unless you define the boundaries of yourself. But that definition is slippery, and artists are increasingly puzzling out its difficulty: the performances of Cindy Sherman for the camera take her through a baffling range of personæ in which her features both become transformed and yet remain at the same time distinctive. Michael Landy's installation, *Break Down*, extended the concept of self through all his goods and chattels and demonstrated his authority – his authorship – by destroying them systematically, in a modern *auto-da-fé* of consumerist consciousness. For Sherman, the selves are manifest in the protean face and body; for Landy, he can renew himself through discarding all his goods.

By contrast, Tony Oursler is inquiring into inner selves. He is compelled by the twinned mysteries of consciousness and communications technology; in taking the distinctive step of freeing the image from the video monitor or sonic device, he has truly magnified the eerie atmosphere that his cast of disembodied messengers cast about them.[10] Indoor pieces, such as *Stone Blue* (1995) and *Insomnia* (1996) include floating, distorted faces speechifying and rambling in Oursler's characteristic post-Dada techno-babble. They extend into a metaphysical dimension the existential riddle posed by cartoon characters, who exist only in 'picture-flesh', walking talking apparitions, possessing no referent in the actual world. Oursler's work with dummies and automata and projections realises the point where spooks and spectres coincide with the phantoms of film, of LEDS, and of other digital means.[11] Analogously, whereas an eighteenth-century automaton mimicked real life and inspires delight, wonder and fear through the disturbing convincingness of its life-

likeness,[12] Oursler's permutations of the effigy's possibilities produce their peculiar frisson because the conditions of life are discarded, its norms exploded: huge eyeballs disconnected from any body or person, weep and laugh on their own, as if alive; limbless, limp, tiny rag dolls blossom with huge speaking heads.

With *The Influence Machine*, Tony Oursler has moved on from the historical development of automata and audio animatronics, to work another kind of conjuring the illusion of life. In this installation, he revels in the possibilities of another species of 'immortal' created by mechanical illusion: the ghost.

The Influence Machine dramatises spirit visions and visits. Oursler draws on existing accounts of messages transmitted from other worlds and departs from conventional orthodoxy about mind-body unity, and space-time confines. In this outdoor urban phantasmagoria, the artist beamed onto trembling foliage and interlaced branches, and high up onto the surrounding buildings of an urban park/garden looming, vast close-ups of out-of-body messengers, men and women with stories to tell of wanderings in other worlds. They describe out of body states and encounters that defy conventional physics. Oursler projected, on one wall of the square a huge fist rapping, as in the first Spiritualist séances, when the Fox sisters reported ghosts knocking for admittance. In the central enclave of the garden/park, the artist conjured up wraiths and mediums to the trees and even on to smoke, so that they dissolved and expanded, loomed and shrank, vaporised and materialised, in a sequence of hypnotic anamorphoses. Oursler's mimicry of séance ramblings surpasses most of the originals that have been recorded; yet the effect is so accomplished, so apparently authentic, and his collaborators' performance so convincing that it was only when I read the transcripts that I realised he had made them up, that he had created a collage of quotes and sampling and historical data about the history of disembodiment.

* * *

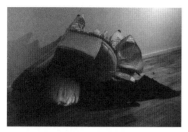

Tony Oursler, *Stone Blue*, 1995

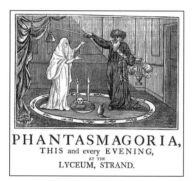

Philidor's *Phantasmagoria*

Medusa's Head used in Robertson's *Phantasmagoria*

The spectacle was inspired by the earliest Gothic popular entertainment, the *Phantasmagoria*. Soon after the Terror, in the same period when the waxworks Chamber of Horrors were beginning to draw crowds as well, the *Phantasmagoria*, or commercial light show, was principally developed through the work of two innovative and spirited showmen or 'galanty men': Etienne-Gaspard Robertson, Belgian-born in 1763, and his younger contemporary, Paul de Philipsthal – also known as Philidor, who was a friend of Madame Tussaud's, who began his version in 1801, and toured widely around Europe, including London and Edinburgh.[13] In his engaging memoirs, Robertson describes his brilliant technical innovations,[14] and Oursler, in tribute to Robertson and in all consciousness of his legacy, has borrowed and adapted many of them for *The Influence Machine.*

Robertson above all was a brilliant innovator: he thought of blacking out the background, so that the projected images would appear to float free in space; he coated the thin, gauzy screen with wax to give it greater translucency and mounted the projector onto rollers so that by pulling it back from the screen, the image would appear to lunge forward at the audience.[15] He experimented with arrangements of lenses and different percussion to create certain special effects, including using a Franklin glass harmonica to strike ghostly notes, something Oursler has also introduced into other works. Above all, in his quest to represent the spectral, Robertson hit upon the idea of projecting onto smoke. One of the few painted slides to survive from his great invention shows the face of Danton from his death mask: as he had only recently been guillotined, the sight of his severed head rising flickeringly above his casket in the curls of the smoke must have been indeed eerie. This Robertsonian invention inspired one of the marvellous effects in *The Influence Machine,* which involves the image appearing and speaking in a veil of smoke. There was no loss of focus as it came and went along the whole length of the beam, so the phantom face appeared to hang in the air in different places, all the time uttering one of Tony Oursler's collages of inner hauntings.

In 1799 Robertson rented an abandoned Gothic convent – the Couvent des Capucines – in Paris, dressed it in antique bric-à-brac and black drapes, painted it with hieroglyphs which, he wrote, seemed 'to announce the entrance to the mysteries of Isis', lit it weakly with 'a sepulchral lamp', and maintained before the spectacle began 'an absolute silence'. The show began with a speech: 'Citizens and gentlemen', he declared, 'It is... a useful spectacle for a man to discover the bizarre effects of the imagination when it combines force and disorder; I wish to speak of the terror which shadows, symbols, spells, the occult works of magic inspire...' He then ended with a flourish, 'I have promised that I will raise the dead and I will raise them.'

The material of the *Phantasmagoria* was Gothic: dancing skeletons, living dead, phantom white ladies and bleeding ghosts, a population of supernatural visitors, in short. One member of the audience at a London séance by Philidor in 1825 gave a lively account of *The Red Woman of Berlin*, who at the climax of the show was propelled to rush at the crowd, looming ever larger: 'The effect was electrical, and scarcely not be imagined from the effect of a written description. I was myself one of an audience during the first week of its exhibition, when the hysterical scream of a few ladies in the first seats of the pit induced a cry of "lights" from their immediate friends, which it not being possible instantly to comply with, increased into a universal panic, in which the male portion of the audience, who were ludicrously the most vociferous, were actually commencing a scrambling rush to reach the doors of the exit, when the operator, either not understanding the meaning of the cry, or mistaking the temper and feeling of an English audience, at this unlucky crisis once more dashed forward the *Red Woman*. The confusion was instantly at a height which was alarming to the stoutest; the indiscriminate rush to the doors was prevented only by the deplorable state of most of the ladies; the stage was scaled by an adventurous few, the *Red Woman's* sanctuary violated, the unlucky operator's cavern of death profaned, and some of his machinery overturned, before light restored order and something like an harmonious understanding with the cause of alarm.'

One has to remember that the blow-up, the zoom, the close-up, the general magnification of the image by

projection with which the movies have entirely familiarised us were first realized by these proto-cinéastes, the phantasmagorists.

The new taste for the ghostly and the gruesome in public entertainment at the turn of the century coincides with another, crucial development in ways of seeing, most powerfully expressed in Goya's great sequence of fantasy images, the *Caprichos*. The series opens with the famous engraving, *The Dream of Reason Produces Monsters* (1797-99), in which Goya represents the melancholy brooding of his own imagination, thereby crystallising a shift from conceiving the imagination as an organ that processes external perceptions to one that summons internal fantasies. The fantastic moves from a higher – or lower – supernatural world into a world of personal visions. However impalpable or imponderable, divine beings, angels and devils existed in the Christian order of creation, independently of an individual's imagination. The enlightened view that optical phenomena were natural, scientifically produced by human skill in interpretation or staging, had the effect of situating the fantastic in a new, paradoxically modern and wholly unstable habitation in the single mind of a person, in the imagination; it becomes one with the subject or dreamer or melancholic or writer or artist's vision and it no longer reveals a true if shadowy world beyond this world.

So, while impresarios like Robertson and Madame Tussaud were perfecting brilliant new technologies to commemorate the departed and make the dead visible again amongst us, the spiritual system that had upheld beliefs in the independent and external existence of ghosts, inhabiting the afterlife, was being undermined. This is what Terry Castle, in her entertaining book *The Female Thermometer* (1995), argues: that the eighteenth century invented the uncanny. 'The historic Enlightenment internalization of the spectral –' she writes, 'the gradual reinterpretation of ghosts and apparitions as hallucinations, or projections of the mind – introduced a new uncanniness into human consciousness itself.'[16]

Terrors of the night, spectres and phantoms ceased to be thought of as immortal souls of people who are wandering around in hell, or purgatory, or perhaps even in heaven, created by God. They were beginning to be understood, as Goya implies so strongly, as fantasies in the head, what the writer on consciousness Antonio Damasio calls 'the movie-in-the-brain'.[17]

The point of invoking this historical shift here is that Tony Oursler's *The Influence Machine*, created in the new millennium, derives from a clinically paranoid, disturbed, fragmented concept of human personality. As in its psychoanalytical origins, it projects extreme and unusual cases of mental disturbance into the common arena of experience and reads human personality in general in its anamorphic shadow. The story Oursler tells in *The Influence Machine*, and in numerous pieces that preceded it, is one of romantic individuality decentred, evacuated and occupied, haunted and unhoused, the self multiplied and scattered, cellular memories rampant and contradictorily on the loose inside the mind and body of a person; Oursler presents this story as generic in our time. *The Influence Machine* is no less than a mise-en-scène of contemporary existence, in his words, a psycho-landscape.

Tony Oursler's work, which is using the new media and new concepts of physics and psychology, is continuing the inquiries of a long and great tradition of natural magic. But there has been another crucial shift, since Robertson created the *Phantasmagoria* in Paris in the 1790s and Goya drew the monsters in his own head. The showman Robertson believed he was throwing light in the spirit of the new age, on the processes by which superstitious credence in miracles and devils and spectres had duped people, and Goya's ironies and satire struggled against fantasy and credulity. By contrast, the spectres that haunt us now have achieved the unsettling cartoon being of media reality; they have also regained their mystery and power to disturb. For, as one of Tony Oursler's apparitions says: 'It sure is dark out here'.

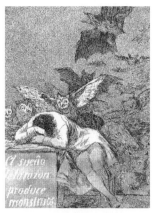

Francisco Goya, *The Dream of Reason
Produces Monsters*, 1797–99

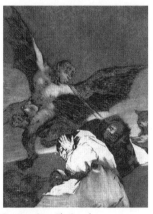

Francisco Goya, *The Squealers*,
No. 48 from *Caprichos*, 1797–99

Francisco Goya, *Bon Voyage*,
No. 64 from *Caprichos*, 1797–99

1 See the catalogue *Noise*, eds. Simon Shaffer and Adam Lowe, Kettle's Yard, Cambridge, 2000.

2 See Michael Roth, 'Hysterical Remembering', in *Modernism/Modernity* 3:2 (1996), pp. 1–30; Lawrence Rainey, 'Taking Dictation: Collage Poetics, Pathology, and Politics', *Modernism/Modernity* 5:2 (1998), pp. 123–153; Roger Luckhurst '(Touching on) Tele-Technology', in *Applying: To Derrida*, eds. John Brannigan, Ruth Robbins, Julian Wolfreys (London, 1996), pp. 171–183; Steven Connor, 'The Machine in the Ghost: Spiritualism, Technology, and the "Direct Voice"', in *Ghosts*, eds. Buse and Stott, London, 1999, pp. 203–225.

3 Steven Connor emphasizes the aural desires, arguing, 'an observational, calculative scientific culture organized around the sequestering powers of the eye began in the last quarter of the nineteenth century to produce new forms of technology especially communicative technology, which themselves promoted a reconfiguring of the sensorium in terms of the ear rather than the eye.' I am very grateful to Steven Connor, for letting me see his unpublished paper, 'Voice, Technology and the Victorian Ear', from the conference *Science and Culture 1780–1900*, Birkbeck College, London, September, 1997. His book *Dumbstruck: A Cultural History of Ventriloquism*, Oxford University Press, 2000, came out after this essay was written.

4 William James, 'Frederic Myers's Service to Psychology' [1911], in *Essays in Psychical Research*, Cambridge, Mass., 1986, p. 196; quoted Rhodri Hayward, *Popular Mysticism and the Origins of the New Psychology, 1880–1910*, PhD Thesis, University of Lancaster, 1995, p. 133.

5 A.K. Coomaraswamy, 'A Figure of Speech or a Figure of Thought?' in *The Door in the Sky: Coomaraswamy on Myth and Meaning*, ed. Rama P. Coomaraswamy, Princeton, 1997, pp. 113–142.

6 Victor Tausk 'On the Origin of the "Influencing Machine" in Schizophrenia', *The Psychoanalytic Quarterly*, Vol. 2, 1933, pp, 519–556, 521. I am grateful to Mark Cousins for this reference.

7 Daniel Paul Schreber, *Memoirs of My Nervous Illness*, New York, 2001, pp. 54–55.

8 *Beyond Reason, Art and Psychosis. Works from the Prinzhorn Collection,* Hayward Gallery, London, 1996.

9 Théodore Flournoy, *From India to the Planet Mars*, ed. Sonu Shamdasani, Princeton, 1994.

10 See 'In the Green Room: Tony Oursler and Tracy Leipold in Conversation with Louise Neri', *Parkett* 47 1996, pp. 21–27.

11 See Donald Britton, 'The Dark Side of Disney', in Bernard Welt, *Mythomania: Fantasies, Fables and Sheer Lies in Contemporary American Popular Art*, Los Angeles: Art Issues Press, 1996, especially p. 122 for a sharp discussion of cartoon reality.

12 Daniel Tiffany, *Toy Medium: Materialisation and Modern Lyric,* University of California Press, 2000.

13 The cinema historians Laurent Mannoni in France, David Robinson and Tom Ruffles have written vividly about their spectacular experiments, while the magic lanternist Mervyn Heard has researched their methods in order to recreate them today.

14 *Mémoires récréatifs, scientifiques et anecdoctiques d'un physicien-aéronaute*, Paris, 1830.

15 Early cinema drifted, as if naturally, to depicting the inner world of imagination. Think of pioneers like Georges Mélies, who filmed a journey to the moon as well as the frolics of fairies, or great silent movies like F.W. Murnau's vampire movie *Nosferatu* or Robert Wiene's *The Cabinet of Dr Caligari*.

16 Terry Castle, *The Female Thermometer: Eighteenth-Century Culture and the Invention of the Uncanny*, Oxford University Press, 1995.

17 Antonio Damasio, *The Feeling of What Happens: Body and Emotion in the Making of Consciousness*, Harvest Books, London, 2000.

TONY OURSLER TIMESTREAM: I HATE THE DARK. I LOVE THE LIGHT.

Religion / Mythology / Philosophy Optics / Still & Moving Images Computers / The Internet

Physics / Mechanics / Electronics Telecommunications Quackery / The Occult / Spiritualism

Egyptian god Seth

Red Seth, the Egyptian god most associated with evil, is depicted in many guises: a black pig, a tall, double-headed figure with a snout, and a serpent. Sometimes he is black, a positive color for the Egyptians, symbolic of the deep tones of fertile river deposits; at other times he is red, a negative color reflected by the parched sands that encroach upon the crops. Jeffrey Burton Russell suggests that "it is possible that the redness of Seth helped make red the second most common color, after black, of the **Christian Devil**."

Your own hands shaped me, modeled me; and would you now have second thoughts and destroy me? You modeled me, remember; as clay is modeled, and would you reduce me now to dust? (Job 10:8–9)

Homer equates the **rainbow/Iris** with a serpent, a sentiment shared in African mythology, in which the colors materialize as a giant consuming snake attacking the unsuspecting. In the tribal myths of South America we find the rainbow personified in evil figures, and in Eastern Europe the colored light sometimes sucks up water and children.

The prophet **Zoroa** **Persia** describes a similar to the Chris Devil. He teaches **Ahura Mazda**, the light, is in battle w evil Angra Mainyu. ist, Zoroaster belie world is divided be dark and light.

Fifth century BC Chinese philosopher **Mo Ti**, in the first description of the **camera obscura**, refers to the pinhole as "collection place" and "locked treasure room."

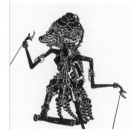

Balinese shadow puppet

Plato's Cave depicts the dilemma of the uneducated in a graphic tableau of light and shadow. The shackled masses are kept in shadow, unable to move their heads. All they can see is the wall of the cave in front of them. As a result of being locked into physical sense perception, they are doomed to view only shadows of truth on the wall of the cave. In Plato's metaphor, an unseen fire behind the shackled illuminates a marionette or puppet show taking place above and behind their heads; the puppets' movements represent the interactions of true contemplation, visible to the masses only as indecipherable shadows projected on the cold stone before them.

Symyaz leads the **fallen angels**. *According to Enoch, they came to earth of their own free will at Mount Hermon, descending like stars. This description gives rise to the name Lucifer, "giver of light."*

"And now there is no longer any difficulty in understanding the **images in mirrors** and in all smooth and bright surfaces. The fires from within and from without communicate about the smooth surface, and from one image which is variously refracted. All which phenomena necessarily arise by reason of the fire or the light about the eye combining with the fire or ray of light about the smooth bright surfaces. Or if the mirror be turned vertically, the face appears upside down and the upper part of the rays are driven downwards, and the lower upwards." (**Plato** [427-347 BC], Timaeus. Translation by B. Jowett, *The Dialogues of Plato* [Oxford, 1875]).

Archimedes (ca. 287–212 BC) is said to have used a large **magnifying lens** or burning-glass, which focused the sun's rays, to set fire to Roman ships off Syracuse.

Aristotle (384–322 BC) writes *De Meteorogia*. His treatise devotes a substantial amount of space to a penetrating discussion on the **causes of the rainbow, luminous halos, northern lights**. This section may in fact be taken as the first truly systematic theory of the rainbow that has come down to us:
"Why is it that the voice which is air that has taken a certain form and is carried along often loses its form by dissolution, but an echo which is caused by such air striking on something hard does not become dissolved and we hear it distinctly? Is it because in an echo refraction takes place and not dispersion? This being so the whole continues to exist and there are two parts of it of similar form; for refraction takes place at the same angle. So the voice of the echo is similar to the original voice."

During an eclipse Aristotle notices many images of a crescent sun on the ground below a tree. He later discovers that whatever the shape of the **aperture**, jagged or smooth, the images projected are the same. The riddle is known as **Aristotle's Problem**.

Circa 300 BC **Euclid** publishes *Optics*, in which he isolates the concept of a beam of light, suggests the eye sends out visual rays to the object that the viewer wishes to see.

Get behind me Satan! You are an obstacle in my path...
(Matt. 16:23)

I have seen Satan fall like lightning from heaven.
(Luke 10:18–20)

First reference to the **persistence of vision**: "This [perception of motion] is to be explained in the following way: that when the first image passes off and the second is afterwards produced in another position, the former is seen to have changed its gesture."
(**Titus Lucretius Carus** [98–55 BC])

Green In the Book of Revelations it is stated, "There is a need for shrewdness here: if anyone is clever enough he may interpret the number of the beast: it is the number of a man, the number is 666." One theory of the number's puzzling origin has anti-Roman groups giving letters numerical significance so that coded messages could be passed among themselves. By obscure calculation **the number 666** has the letter value of Nero, who ruled 54–68 AD. Nero is known to have enjoyed peering through a rudimentary lens crafted of the gemstone emerald, which has the property of enlargement. This is one of the first records of the use of a lens. As no records exist past the bare facts, one can only imagine the joy the emperor must have felt.

Black Darkness becomes a palpable mass that occupies the room completely. It expands to fill every void within the chamber, including our eyes. Perhaps there is something there that can see us and take advantage of our b

hristians link the colors of the rainbow
the seven sacraments.

The Comic Devil appears in popular medieval dramas. His role is slapstick – screaming oaths, making obscene gestures, and executing prat-falls. Like Hell, the character was an inversion of norms of the day.

"**Vision** is of three kinds: direct in those who are perfect, refracted in those who are imperfect, and reflected in evildoers and those who ignore God's commandments." (**Roger Bacon** [1214–92])

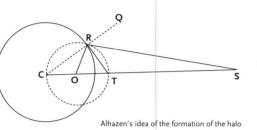

Alhazen's idea of the formation of the halo

Ibn al-Haytham (a.k.a. Alhazen), a tenth-century Arabian scholar, publishes *Optics*, which is the basis of Europe's knowledge on the subject until the sixteenth century. In it he describes the **camera obscura**. He also expands on the optical understanding of the Greeks, explaining that light spreads out in all directions from an object. In addition he describes the linearity of light through the use of three candles and one pinhole, proving that we see objects by viewing light reflected from them.

Shen Kua (1031–95), Chinese astronomer, mathematician, and poet, expresses the first moral equivalent of the inherent quali-ties of the **camera obscura**. He makes an analogy between the camera obscura's image inversion and the nature of man's vision, which can be so polluted as to see right as wrong.

In the thirteenth century, **Arnaud de Villeneuve**, showman and magician, utilized the **camera obscura** to stage presentations somewhere between shadow play and cinema: players performed warlike or murderous episodes outside in the bright sunlight, while inside the audience was shocked and delighted by sound effects linked to the dramatic gestures of the projected images. The fact that the audience would stay inside and watch such a mediated event when they could have gone outside and viewed the event directly points to a victory of the virtual image over reality. The disembodiment of the moving image and its removal from the recognizable physical laws that bind the body of the viewer imbue the image with a magical quality at once distant and intimate. Thus, a new space is created, one of activated viewing, which will later incorporate many forms of cultural production – a space of collaborative creativity between darkness and light.

Robert Grosseteste (c. 1175–1253) translates the works of Alhazen to Latin.

French astronomer **Guillaume de Saint-Cloud** suggests in an almanac of 1290 that viewers of an **eclipse** use a hole in their roof and a board as projection screen to avoid blindness from staring directly at the sun.

"Alhazen, who was no fool, wrote his *Treatise on Aspects*: the wise naturalist who would learn about the rainbow must consult this book and must also possess notions of geometry to understand the demonstrations in this treatise. He will then be able to find the causes and the potency of glasses which possess marvelous qualities: the smallest things, the most minute lettering, tiny grains of sand, are seen so big and thick that they can be exactly distinguished and even counted from afar, which seems incredi-ble to one who has not seen them or does not know the causes thereof. Others burn and consume things placed before them if the rays of the sun which strike them are cunningly made to con-verge... Others cause different images to appear, straight, oblique or reversed. So that mirrors according to how they are arranged, can show two objects instead of three, eight instead of four." (**Jean de Meun**, Roman de la Rose)

position. Gone is the steady stream of images absorbed into the eyes. All stimulation is halted as blood, nerves, and retinas self-animate – sparks fly, points of false light deceive us. In the dark, the eye or brain or chemical state or

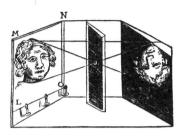

Giovanni Battista della Porta, 1558

Albrecht Dürer (1471–1528) illustrated two **drawing aids**: one involving a grid through which to view images, and another using a ground glass pane to trace images from life.

Formula for a Homunculus
"Place human semen in a glass vial and nourish with blood for forty days and forty nights, keeping it at the temperature of a horse's belly: and from it will be born a genius, a nymph, or a giant."
(Philippus Aureolus Theophrastus Bombastus von Hohenheim [1493–1541], better known as Paracelsus)

1558 **Giovanni Battista della Porta** publishes details of construction and use of the **camera obscura** in the widely distributed and popula *Magiae naturalis*:
"First of all you must close the windows in the room; you will make round hole the size of one's little finger and opposite you will stretc pieces of white sheets or white cloths or paper; and the result will b that all things which outside are illuminated by the sun you will see inside, you will see those walking in the streets with their heads do wards, as if at the antipodes, and the things on the right will appea on the left and all things turned over and the further they are from hole the larger they will appear.
I will not conceal at last a thing that is full of wonder and mirth, beca am fain upon this discourse, that by night an image may seem to ha the chamber. In a tempestuous night anything may be represented ha in the middle of the chamber, that will terrify beholders. Fit the image before the hole that you desire to make seem hanging in the air in an chamber, that is dark; let there be many torches lighted around abou the middle of the dark chamber place a white sheet, or some solid that may receive the image sent in; for the spectators will not see t sheet, will see the image hanging in the middle of the air, very clear without fear or terror, especially if the artificer be ingenious... you see hunting, battles of enemies and other delusions, and animals t are really so, or made by art of wood or some other matter. You mu frame the little children in them, as we used to bring them in when comedies are acted; and you must counterfeit stags, boars, rhinocer Later he discovers that by adding a lens to the enlarged hole, imag can be sharpened.

1585 **Tulio Cesare A** focuses sunlight th flask of water and p it into the nasal cav is the first person to use a light sourc an **endoscopic pro**

Anonymous engraving, *The Soul of Man*, 1629

"For since God has given each of us a light to distinguish truth from falsehood, I should not have thought myself obliged to rest content with the opinions of others for a single moment if I had not intended in due course to examine them using my judgment; and I could not have avoided having scruples about following these opinions, if I had not hoped to take every opportunity to discover better ones, in case there were any." (**René Descartes**, *Discourse on the Method of Rightly Conducting One's Reason and Seeking the Truth in the Sciences*. First published anonymously in 1637)

1610 **Achilles Landenbucher**, a watchmaker, devises musical instruments that play themselves.

"I will suppose therefore that not God, who is supremely good and **the source of truth**, but rather some malicious demon of the utmost power and cunning, has employed all his energies in order to deceive me." (**René Descartes** [1638–40], *Meditations on First Philosophy*, 1641)

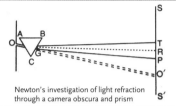

Newton's investigation of light refraction through a camera obscura and prism

1604 The astronomer **Johannes Kepler** writes *Ad Vitellionem paralipomena*, in which light and the physiology of the eye are explored in depth. He coins the term **camera obscura**, which had been known variously as conclave obscurum, cubiculum tenebricosum, and camera clausa. By using this device he is able to measure the diameters of the sun and moon. He also demonstrates how the focal distance of a lens can be reduced by interposing a negative concave lens; this may be the first description of a **telephoto lens**. As imperial mathematician, Kepler used a portable tent camera obscura to survey Upper Austria.

1646 **Athanasius Kircher**, a German professor of philosophy, mathematics, and Oriental languages at a Jesuit college in Rome, publishes *Ars magna lucis et umbrae*. It includes the earliest known illustrations of **magic lantern slides and the first descriptions of lantern shows** and other devices such as **dioptrics, lenses of pantoscopes, and telescopes**, in "which little known powers of light and shadow are put to diverse uses." Two lenses can be put together to create a microscope, "which will amplify a fly into a camel." Kircher also describes a portable camera obscura with two apertures and an inner cube. The outer box has a hole on one side facing another hole on the opposite side. Inside is another box or frame covered with translucent paper. The draughtsman within is able to see an image on two sides of the little paper-walled room. Kircher describes **persistence of vision**, likening the change of color in an after-image to the glow of a phosphorous stone when placed in darkness after exposure to light.

1647 **Johannes Hevelius**, an astronomer, designs a lathe that can produce **large-scale telescope lenses**.

1666 **Sir Isaac Newton** studies the **phenomena of colors**, laying the groundwork for the modern physical theory of color. To begin, he creates a camera obscura with a triangular **glass prism** at its "entrance," which he grinds himself, focusing and refracting the sun's rays through the dark room onto the opposite wall. There it is "a very pleasing divertissement [diversion] to view the vivid colors" of the spectrum. These experiments culminate in his letter of February 6, 1672 to the Royal Society of London, which outlines his discovery of the properties of light rays. Newton also notes that the relative color or perceived color of objects is determined by the quality of the light striking the object. For example, an apple tends to reflect red in a full spectrum of light. As Newton points out, it is useless to think of an apple as red, for "any body may be made to appear any color" by controlling the reflected light. Newton is also the first person in history to unlock the riddle of the rainbow when he applies his understanding of refraction to the water droplets in the air.

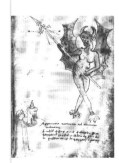

Giovanni da Fontana, 1620

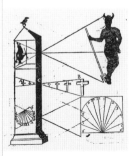

Althanasius Kircher's parastatic machine, engraving for *Ars magna lucis et umbrae*

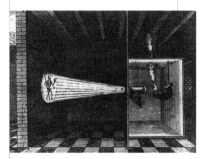

Althanasius Kircher: la "lampe magique ou thaumaturge"

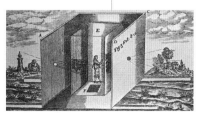

Althanasius Kircher's double camera obscura engraving for *Ars lucis et umbrae*

"All Knowledge is light and all proceeds from the First, Infinite Light Who is God." (**Athanasius Kircher** [1601–80])

1720 **Louis-Bertrand Castel** invents the *clavecin oculaire* or **optical harpsichord**. The keys trigger not only sound but als a corresponding color produced by transparent colored gel

1675 **Jean Picard**, the French astronomer, is walking home late one night from the Paris Observatory, swinging his barometer by his side. To his great surprise, the glass tube emanates a faint glow; the more he shakes it the more it glows: **"the glow of life."**

1706 **Francis Hauksbee**, an English student of Sir Isaac Newton, invents a machine that produces "the glow of life" at will. Hauksbee's **Influencing Machine** consists of a hand-cranked device that spins a glass vacuum globe, half full of air. The mysterious luminosity can be produced by touching the surface of the glass as it spins; also produced is a crackling sound that reminds the inventor of lightning.

1717 **Richard Bradley** describes the **kaleidoscope** in a work on garden design.

Hauksbee's Influencing Machine

1725–27 **James Graham** establishes the **Temple of He** in London. He invites childless couples to indulge in intercourse in his celestial or magneticoelectro bed a therapeutic electric field created by Hauksbee's Influencing Machine.

cques de Vaucanson amazes the world by exhibiting a number of **automata**, including a life-size Flute and the celebrated Duck, which is reported to flutter gs, swim in water, eat, drink, and, finally, pass the food rphous matter.

1745 Pieter van Musschenbroek invents the **Leyden jar**, a storage container for a continuous flow of relatively large amounts of electricity, considered the first battery. Previously, experimental scientists were forced to rely on unpredictable, spontaneous electrical phenomena such as static electricity or attracting lightning to a metal pole, for example.

1746 Abbe Nollet conducts **electricity** from a Leyden jar through the bodies of Carthusian monks holding iron wire. The monks form a circle 5,400 feet in circumference. The simultaneously shocked contortions that the monks display, when the circuit is closed, proves that electricity is felt throughout the entire circuit and that electricity travels very quickly.

Etienne de Silhouette (1709–67), French Controller General of Finances, cuts out profiles of his contemporaries in black paper.

1749 Horace Walpole, a young British socialite, begins to convert his home, Strawberry Hill, into "a little Gothic castle." The interior is to become a repository of everything antique; when he can't find an object he desires, he employs artisans to build a replica for him. His random collection of oddities from throughout the ages, such as a Roman tomb with the bones of a child within, are aesthetically arranged. The towers and stained glass are not in themselves designed to evoke fear; the setting is meant to stimulate visitors to feel a bygone era when our predecessors believed dwellings to be haunted. This influential building may be seen as the origin of a resurgence of Gothic and the camp/pop cultural interpretation of the past that is so prevalent today in theme parks, architecture, and media.

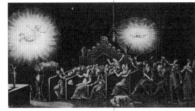

Illustration of Robertson's *Phantasmagoria* from his *Mémoires*

Robertson's redesign of Archimedes legendary Burning Glass for the French Government

1763 Etienne-Gaspard Robertson, showman-scientist-occultist, is born in Liège. In his memoirs Robertson writes of his fascination with "Father Kircher" and of the early motivations that he shared: "Who has not believed in the Devil and werewolves in his early years? I admit frankly that I believed in the Devil, in raising the dead, in enchantments... Since the Devil refused to communicate to me the science of creating prodigies, I would apply myself to creating Devils, and I would have only to wave my wand, to create all the infernal cortege to be seen in the light. My habitation became true Pandemonium."
By the 1790s he shifts his exploration from the occult to the science of optics and, finally, to a new theatrical form. In 1794 Robertson founds the **Fantasmagoria**, an influential sound and light show in Paris, which makes use of his own graphic designs and innovations in the magic lantern projection system. He combines performers, props, and sound effects produced by the Musical Glass (and a robotic trumpet player) and projects moving images on clouds of smoke and layers of gauze curtains. In the area of slide projection, he introduces the idea of painting images on an opaque black background rather than on clear glass – so the images seem to float free in the air. His theater, a "vast abandoned chapel" dressed up with elaborate "Gothic" decor, is the first permanent auditorium (he performs the *Fantasmagoria* for six years) for projected audio-visual shows. So convincing are his illusions that "gentlemen drew their swords, ladies fainted." He insists that his aim is not to deceive the public but to arm them against irrational superstition. His themes are culled from popular lore, historic and religious: *The Apparition of the Bleeding Nun, Chinese Tamtam, The Death of Lord Littleton,* and *Preparation for the Sabbath.*

1766 Jean-Jacques Rousseau coins the word **melodrama** to describe a drama in which words and music, instead of proceeding together, are heard in succession, and in which spoken phrases are to some degree announced and prepared for by musical phrases.

1773 Jean Pierre and **Henri-Louis Droz** produce **The Scrivener**, a robotic writing figure who dips his pen into an inkwell and writes a limited number of words.

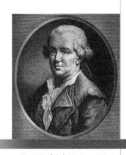

Friedrich Anton Mesmer

1784 Friedrich Anton Mesmer, an Austrian physician, is legally forbidden to practice in France. His treatments involve groups of patients conducting the current known as animal magnetism through chambers, huge vats, or metaphorical "batteries" of mysterious solutions. The treatments, accompanied by shouts, hysterical laughter, and music, end in mattress-lined rooms for the patients' decompressions.

1800 **Humphry Davy**, English electro-chemist, is the first to observe the light produced by the discharge of electric current between two carbon electrodes. The **arc light** is produced.

1817 Swedish **Baron Jöns Jakob Berzelius** isolates the element **selenium**.

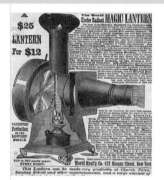

Magic lantern

1806 **Bozzini** employs an aluminum tube to visualize the genitourinary tract. The tube, illuminated by candle light, has fitted mirrors to reflect images. Bozzini's invention, "**a magic lantern in the human body**," is ridiculed at the time.

1814–26 **Joseph Nicéphore Niepce** achieves his **first photographic images** with a camera obscura.

1817 What is the normal state of a room? O say that a dark room is a more natural and tive state than a lighted room. As with the c before it, the room is enclosed and inherent from natural light. Windows can be employ light and air into a room, but daylight is lim the cycles of the sun. At night artificial light ed to illuminate the chamber. The open fire to more controlled forms of light: oil lamps and finally, in cities, systematically supplied

1802 **Thomas Holcroft**'s play, *A Tale of Mystery: A Melodrama*, is innovative in its use of music and calls for intensifying dramatic moments by the sonic expression of "discontent and alarm," "chattering contention," and "pain and disorder." Over the next forty years, stage music evolves into a modular system of repeatable phrases known as melos, each identified with a different emotion.

1833–38 **Michael Faraday** investigates **electrical discharges** of gases using vacuum tubes in which a current is passed from a negative electrode to a positive electrode, producing a glow on the inner surface of the opposite end of the tube.

1841 **Frederick de Moleyn** first uses vacuum for **electric light bulbs**.

1831 **Joseph Henry**'s single-wire **telegraph** is introduced.

1832 Electric currents can travel rapidly along wires of infinite length. **Samuel Morse** interrupts the current and shapes it into combinations of dots and dashes to represent the twenty-six letters of the alphabet, the ten numerals, and all punctuation marks. The Morse code foreshadows the on/off nature of binary code – a series of zeros and ones – used in modern computers.

1842 **Alexander Bain** elaborates on Edmond Becquerel's research into the **electromechanical effects of light** and proposes the idea of scanning an image so that it can be divided into small, transmittable parts. According to his theory, electrified metal letters could be scanned by a pendulum and duplicated on chemical paper at the other end of the telegraph wire by a synchronized pendulum.

1844 **Samuel Morse** sends the **first message by electric telegraph** from the Supreme Court in Washington D.C. to Baltimore. Miss Elsworth, the daughter of the commissioner of patents, composes the message: "What hath God wrought."

25 **Peter Mark Roget** of thesaurus fame demonstrates e **persistence of vision** with his Thaumatrope.

1832 **Charles Wheatstone** invents a non-photographic "**stereoscopic viewing device**."

1843 **Rogues' Gallery**: The first index of photographed criminals is organized by the police of Brussels.

1843 **Fox Talbot** makes **first instantaneous photographs** using electric spark illumination.

1850s In a lawsuit against Thomas Edison, **Heinrich Gobel**, an American of German descent, is ruled to have made "a truly serviceable, practical **incandescent lamp** and exhibited it publicly twenty or thirty years before Edison."

1859 Establishing an important principle for the future of **electronics**, the German mathematician and physicist **Julius Plücker** discovers that cathode rays (electrons) are deflected by a magnetic field.

1858 Heinrich Geissler, a German glass blower and maker of scientific instruments, creates the **Geissler tube**. A vacuum is created in a glass container sealed with electrodes at either end. Electrons moving through the tube are visible as patterns of light, varying according to the shape of the tube or the type of gas introduced into the vacuum. This invention will lead to the discovery in 1890 of cathode rays, a basic principle of video technology.

1859 Alexandre Edmond Becquerel, a member of the noted family of French physicists, uses a Geissler discharge tube filled with fluorescent material to create the **first fluorescent lamp**.

1860 Oliver Wendell Holmes invents popular **stereoscope viewer**.

1864 Lewis Morris pioneers **astrophot**

The Fox House in Lily Dale, New York

1851 The Fox sisters gave public demonstrations of their communication with the sprit world. As their fame grew so did the controversy around their unique physical phenomena. Charges of demonic possession and fraud were leveled at the girls and they submitted to traumatic examinations. Some doctors conclude that the Fox sisters produce the rappings themselves with their big toes and knees, which were said to be double-jointed. Leah Fox describes the invasive medical examination of the three sisters in Buffalo, New York: "Major Rains was an educated chemist and fine electrician. He arranged a swing, which was fastened to iron or steel chains, sustained by tackles and pullies attached to the ceiling. I sat in the swing, and over my head was a large glass of circular form, about two and a half feet in diameter, and beneath my feet (which were about four feet from the floor) was a steel circular disk about three feet in diameter. The whole arrangement was suspended by the tackles. Major Rains brought his electrometer, and made every experiment that their ingenuity could invent or suggest. They suspended the table; each person in the room standing on horseshoe magnets provided for that occasion. The physicians were provided with stethoscopes, and placed them on different parts of my person..." (Anne Leah Underhill, *The Missing Link in Modern Spiritualism* [1885])

1860–80 Photographic lightning is believed to be a flash of lightning that creates the image of a person on an ordinary windowpane or mirror. In American folklore the legend encompasses the possibility that sick, dying, or dead people leave images of themselves on glass surfaces in the building of their confinement. The subjects are criminals, victims, and sometimes Jesus Christ. Folklorist Barbara Allen suggests that popular misunderstanding of the new technology such as the photographic plate spawned such lore, and with the introduction of flexible film, the glass plate legends decline.

Katie Fox recalls a séance: "... the voice of Benjamin Franklin was heard, in raps. The medium was a member of the family where the test occurred. After a silence of one or two minutes, a violent shock of her person induced one hastily to say:
Q. What is the matter? Are you waking up?
A. No, you wanted a signal, and I told him, if it was Dr. Franklin, he might electrize me, and he did it.
Q. Has it injured you?
A. No, I feel better; my head is clearer – I can see plainer." (W.G. Langworthy Taylor, *Katie Fox and the Fox-Taylor Record*, compiled 1869)

1848 On March 31 the **Fox family** (John, Margaret and daughters Kate, Leah and Margaretta) of Hydesville, New York, retire for the evening. As usual, their slumber is interrupted by violent knocking sounds. Comfortable with the inexplicable knocks by now, the girls playfully personify the invisible mysterious generator of sound.
Katie: Here Mr. Split-foot, do as I do.
Katie claps her hands three times, the spirit knocks three times. Mother Margaret tests the spirit by asking the ages of her daughters, and the spirit responds correctly. Word of the "new telegraph line that connects to the spirit world" spreads rapidly, thus the **New American Spiritualist Movement** begins.

Katie Fox

1869 **Edward Everett Hale**'s "The Brick Moon" is published in *Atlantic Monthly*. Hale describes an artificial moon, or **satellite**, that he thought could be used as a military post.

geons are used to carry microphotographed essages across enemy lines.

1872 **Joseph May**, a worker at Telegraph Construction and Maintenance Co., tests transatlantic transmissions using rods made of **selenium** as resistors. He finds the resistance to be inexplicably variable; his lab desk is near a window, and he notices that when a ray of sunlight strikes the test rods, current flows freely through it, while in the dark the electricity crawls. The company's head electrician, Willoughby Smith, later takes credit for the discovery. Recognizing the implications of the phenomenon, he follows up with extensive experimentation and proposes "visual telegraphy." He states at the time, "Selenium's sensibility to light is extraordinary... a mere Lucifer match being sufficient to effect its conductive powers."

1876 **Alexander Graham Bell**, trained in speech therapy for deaf people, patents the **telephone**. "The telephone operates by translating vocal sounds into a fluctuating electric current, which passes through a wire and is converted back into vocal sounds by a receiver at the other end of the wire" (Christos J. P. Moschovitis, Hilary Poole, Tami Schuyler, Theresa M. Senft, *History of the Internet: A Chronology* [1999])

1870 **The Final Camera Obscura: The Corpse. Dr. Vernois** of the Society of Legal Medicine of Paris publishes his theory of the optigramme. He believes that at the point of death, the retina freezes the last frame of one's life and retains the image until decomposition of the body. The forensic implications of the theory are explored by surgically removing the retinas of murder victims and examining them under a microscope.

Sincere Acting: "This woman's nature was one in which all... experience immediately passed into drama, and she acted her own emotions... It would not be true to say that she felt less because of this double consciousness." (George Eliot, describing Princess Halm-Eberstien in *Daniel Deronda* [1868])

1879 General Electric introduces the first Edison **carbon filament electric light bulb**.

1885 **Artificial lighting** during theatrical performances causes audience discomfort; viewers are subjected to extremes of temperature (the ceiling goes from 60 to 100 degrees) and suffer headaches due to the fact that gaslight consumes large amounts of oxygen, while its exhaust includes ammonia, carbon dioxide, and sulfur. In Berlin the effects of gaslight on luxurious public decor and architecture are noted: "The gas flames began their destructive work... blackening the ceilings... most surfaces turned yellow... and the oil paintings almost disappeared or were darkened by smoke."

1880 The first articles written about **early models of television** are published in *Nature, English Mechanic,* and *Scientific American*.

1886–89 German physicist **Heinrich R. Hertz** produces **radio waves**.

1881 Brit **Shelford Bidwell** transmits silhouettes using both selenium and a scanning system. He dubs the device the **"scanning phototelegraph."**

1878 **Eadweard Muybridge** publishes *The Horse in Motion*.

1878 **Dennis Redmond** develops **"electric telescope"** to produce moving images.

1881 **Rudge** and **Friese-Greene** use a lantern with a scissors shutter to animate **consecutive images** of a man removing his own head.

1884 **Etienne-Jules Marey** develops the **chronophotography** device, which looks much like a machine gun. He successfully exposes a number of photographic images in quick succession, thus capturing exact details of motion that have never before been seen. One of his first motion studies is of a flying bird, which he then presents on an electric zoetrope. Marey, a scientist, is interested in using his devices only for speeding things up or down to study locomotion. He shies away from the replication of real time, stating that the absurdity of such an undertaking "would be attended by all the uncertainties that embarrass the observation of the actual movement."

Etienne-Jules Marey, photographic gun

1887 "Look," said the lady, "the gas flames are upside down."
"You are mistaken my dear," replied her husband. "They are electric lamps!"
"That's nice," said the lady, "but what would happen if they were to break? Would it still give out light? Would it leak out into the auditorium? Wouldn't that be dangerous for the audience?"
"My dear wife," said her husband, "one can breathe electricity without the least danger. And in any case, it would rise and collect under the ceiling at once, so we would have nothing to fear."

1888 On February 27 **Eadweard Muybridge** meets **Thomas Edison** and suggests the combination of the respective inventions – the **zoöpraxiscope** and the **phonograph**.

1890 **Heinrich R. Hertz** develops **electromagnetic radiation**. 1893 **Thomas Edison** patents the **kinetoscope**.

1890 The US government undertakes the census of 1890, two thousand clerks are hired to run Herman Hollerith's mechanized tabulating system. This marks the birth of the now-ubiquitous office-machine as well as **IBM**. Clerks translate each citizen's age, sex, and ethnicity into a pattern of holes punched on a card; Hollerith's electromechanical machine totals the information. Each machine processes one thousand cards an hour. The census takes two and a half years. (Christos J. P. Moschovitis, Hilary Poole, Tami Schuyler, Theresa M. Senft, *History of the Internet: A Chronology* [1999])

1896 Italian physicist **Guglielmo Marconi** invents a system that allows electric waves to relay Morse Code messages.

1890 German physicist **Karl Ferdinand Braun** invents the Braun tube, an adaptation of a Lenard cathode ray tube, which is the forerunner of the TV picture tube.

1888 **George Eastman** markets the Kodak, **a roll-film camera** capable of taking 100 separate pictures without reloading. Eastman provides developing and printing facilities: "You press the button, we do the rest." Amateur photographers come into being.

1888 **Frederick Eugene Ives** files patent for taking **color photographs**.

1888 **Dr. Roth** and **Professor Reuss** of Vienna use bent glass rods to illuminate body cavities.

1889 **A. Pumphery** (UK) invents and markets the **cycloidotrope** or Invisible Drawing Master, a machine that will "trace an infinite variety of geometric designs" upon smoked or darkened glass slides for the magic lantern. By turning a hand crank, one produces a rudimentary animation of white or tinted lines on the screen.

1889 **First commercial transparent roll film** makes possible the development of the movie camera.

1889 German scientist **Paul Gottlieb Nipkow** patents an image-scanning machine made up of a spinning disk placed between a scene and a selenium element. Nipkow argues that if the disk is turned fast enough, it can show a **moving picture**.

Cycloidotrope

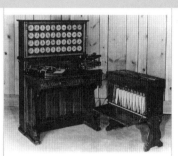
Hollerith's Tabulator and Sorter

1895 Inside Out Inside Outside
1. Inside/Out. German physicist **Wilhelm Conrad Röntgen** discovers **x-rays**; slide makers publish long lists from which to choose interesting and macabre examples ranging from coins in a purse to a bullet lodged in a cranium.
2. Inside. **George Mélies** works as a magician/artist at the Robert-Houdin Theater, which regularly combines lantern shows with performances. On April 4 Mélies shows his first film at the theater, along with Edison's kinetoscope films. Also on the bill are boxing kangaroos, serpentine dancers, seascapes, and white silhouettes on black. He founds first production company, Star Film, which produces 500 films from 1896 to 1912; fewer than 90 survive. Mélies himself plays the Devil in a number of his own films.
3. Outside. On December 28, in front of the Grand Café in Paris, thirty people watch **Auguste and Louis Lumière**'s *Workers Leaving the Lumière Factory*, as the Lumières and Edison demonstrate motion picture cameras and projectors.

1892 **Arsène d'Arsonval** studies the psychological effect of **electrical current on humans**.

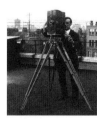
Lumière Bros. first manufactured camera

1897 German **Karl Braun** invents the **cathode-ray tube**.

1900 **Max Planck** introduces the **quantum theory** in physics.

1901 **Marconi** transmits the first **transatlantic radio signals** – the Morse code signal for SSSSSS.

1902 **Otto von Bronk** applies for German patent on **color television**.

1904 **Alfred Korn** announces **facsimile telegraphy**.

1907 English inventor **A. A. Campbell-Swinton** and Russian **Boris Rosing** independently sugge using a cathode-ray tube, instead of the Nipko disc, to reproduce **a television picture** on a pho phorous-coated screen. The vacuum tube can both amplify electrical signals and act as a swit for routing electrical pulses through a circuit.

1897 **Albert Allis Hopkins** publishes the book *Magic, Stage Illusions and Scientific Diversions, Including Trick Photography*, which describes the techniques of photography on a black ground, spirit photography, and duplex photography.

1900 First mass-marketed camera, the **Brownie**, is released.

The Devil and the Statue, 1902. Mélies as Satan

How Mélies head grows in *The Man with the Rubber Head*

1904 **Alfred Maul**, an engineer in Dresden, Germany, sends cameras up in rockets.

A spirit picture

909 GE introduces the Mazda trademark on Edison light bulbs.

1915 "What is that sound? Where is that voice coming from? I don't see anybody, yet I clearly hear a voice speaking to me. It is not inside my head. Could it be God or the Devil? No, it is from inside the machine." **Ray Kellogg** invents the **electric moving-coil speaker**.

1920–21 **Ernst Belin** works on and introduces wireless transmission of photographs.

1921 At fourteen, **Philo T. Farnsworth** devises electronic television scanning. He tells his friends and teachers about it.

1921 **First radio network** established by AT&T.

1921 American **Charles F. Jenkins** engineers a **mechanical television system** based on the Nipkow disk.

909 "Phantom Rides," films shot from the front of a boat or train, are distributed. Audiences find the simulated motion intriguing and disorienting.

1912 **Alfred Maul** sends a gyroscope-stabilized camera up to two thousand feet. It returns to earth in a parachute.

1921 **John Baird** sells his soap business, moves for health reasons from London to the seaside town of Hastings. There he shares a flat with his boyhood friend Guy "Mephy" Robertson, nicknamed for his seeming resemblance to Mephistopheles. In this pastoral setting he decides to try to construct a television. **The world's first working television** was to "grow to fill my bedroom," which he shared with Mephy: "It became a nightmare cobweb of... junk,... At last to my great joy I was able to show the shadow of a little cross transmitted over a few feet." Some of the objects used in the invention: cardboard cross, wires, old hat box, electric batteries, bicycle lamp lenses, used tea chest, sealing wax, glue, scissors, lamp bulbs, darning needles, neon lamp, Nipkow disk, wireless valves, transformers, selenium cells, and electric motors.

Electric Extraction of poisons

1910 **Portable (home) high-frequency electrotherapy** devices are marketed as health aids. These machines send electrical charges through shaped vacuum tubes filled with various gases to send rays into the body. The tubes are held against the skin or eyes or inserted into the nose, mouth, ear, urethra, vagina, or anus. The violet or ultraviolet ray machines are said to cure everything from pain to cancer. The following is a chart of the possible discharges at various vacuums:
1. Normal red vacuum level
2. Slightly higher violet vacuum level
3. Higher yet white vacuum level (note phosphorescence of glass)
4. Highest Crookes vacuum level (note yellow-green phosphorescence of glass from cathode-ray/x-ray formed inside tube)

1915 **A case of paranoia**. **Freud** analyzes a young woman who is convinced that someone is following, watching, and photographing her. She has detected this surveillance by hearing clicking or knocking sounds that she believes to be the shutter of the camera taking her picture. Freud analyzes the aural hallucinations as originating within the woman's body, and the clicks to be an aural displacement of the throb of her excited clitoris.

1920 **Albert Abrams**, M.D., invents a "radionics" system, which uses the crystals of dried blood from a patient to perform as do the crystal detectors of homemade radio and transmit the patient's disease.

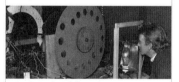

Baird's Nipkow disk, 1922

Sigmund Freud, *rejecting concepts of good and evil, looks upon the Devil as a symbol of the dark, repressed abyss of the unconscious: "The Devil is clearly nothing other than the personification of repressed, unconscious drives." The historical association of the Devil with anal imagery leads Freud to locate him in repressed anal eroticism.* **Carl Jung**, *on the other hand, interprets religion as a necessary expression of the collective unconscious, and God and the Devil as essential archetypes of that system. Jung thinks of the Devil as a union of mythical and psychological repression, which he sometimes likens to the Shadow. For the individual, the Shadow is a highly personalized, unintegrated collection of repressed elements. The Shadow can manifest collectively in groups or in society as a whole, unleashing mass phenomena such as racism, rioting, and war with great destructive force.*

1927 General Electric invents the modern **flashbulb**.

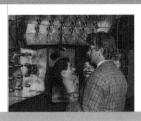

Baird and dummies in his laboratory

1923 **Vladimir Zworykin** applies for patents for a **television picture tube**.

1925 On October 30, **John Baird** transmits his **first decipherable moving picture**: the head of a dummy.

1926 USA Radio Act declares public ownership of the airwaves.

1927 On September 7 **Farnsworth** transmits a straight line, the **first image ever to be transmitted electronically**.

1927 Bell Laboratories performs **the first mechanical television transmission** in the United States.

1927 **Radio** changes from a two-way communication device to a one-way broadcasting device thanks to commercial interests and their representatives in Congress (Radio Act of 1927).

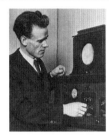

Philo Farnsworth

Purple Television is conceived with the advent of photoconductivity and the further refinement of the photoelectric cell. The notion of translating or coding the bright and dark areas of images into a corresponding electrical signal and decoding it back into an image at another location is within reach. Baird, unable to build a photocell that works, is aware that the light sensitivity of the human eye resides in the purple fluid found in the retina called visual purple. He decides to experiment with a real human eye. He goes to Charing Cross Ophthalmic Hospital, is taken for a doctor, receives a fresh eye wrapped in a cotton wool, and returns to his lab in the attic at 22 Frith Street, London. There he dissects the eye with a razor, and unable to put it to use, throws it into a local canal.

1927 Warner Bros., faced with bankruptcy, launches **sound film**, (*The Jazz Singer*).

1929 On July 17 **Dr. Robert Goddard**, the American rocketry pioneer, launches the **first liquid-fueled rocket** equipped with a camera.

1928 **Panchromatic film** that registers all light in the visible spectrum is developed. So is **infrared film** that is designed to pick up light that is below red on the spectrum, light that is invisible to the unaided human eye, or even an object in no light, just from the heat the object gives off.

1925 **Dinshah P. Ghadiali** is jailed for fraud. He is founder of a nationwide cult in the United States that uses his **Spectrochrome**. His machine, based on a theatrical spotlight, generates and focuses colored light to heal people.

1929 Psychic and paranormal researcher **Joseph Dunninger** hosts the radio show, *The Ghost Hour* for NBC. Dunninger silently communicates three thoughts across the airwaves: the name Lincoln, the number 379, and the image of a small house consisting of four windows, one door, a triangle roof, and a chimney. Two thousand letters arrive at NBC that confirm his success – the writers received the messages.

1936 **Alan Turing** conceives of a punch card system that can do more than add. The theoretical **Turing Machine** mechanically scans a virtually endless tape that is punched with coded instructions or digital sequences of zeros and ones. Turing proves that you can translate all sorts of complex problems into these strings of simple – elemental – operations.

1937 **Chester Carlson** invents **xerography**. 1939 **Electron microscope** developed in Germany.

1934 **Philo T. Farnsworth** publicly demonstrates **electronic television**.

1936 Bell Telephone Co. (BTL) starts exploring a technique to transform voice signals into digital data, which can then be reconstructed (or synthesized) into intelligible voice, the "**vocoder**" (short for voice coder). The research is developed by the National Security Agency (NSA).

1941 FCC authorizes **commercial TV** in the United States. J. Gilbert Wright, a researcher at General Electric, is contacted by Thomas Edison's spirit by way of the medium, Mary Olson. Spirit directs Wright and his partner, Gardner, to the blueprints of the machine for contacting the dead that Edison had supposedly been working on at the time of his death. They faithfully construct this device, which consists of a sound box, a microphone, and a loud speaker, under Edison's supervision.

1942–43 BTL works under direction of **A. B. Clar** (who later led R&D activities of NSA from 1954–55) to develop vocoder that emphasizes the preservation of voice quality via twelve-channel system. This system becomes known as SIGSALY (**Secure Digital Voice Communications**). BTL invents the fundamentals and transmission of digital, encrypted voice. The Institute of Electrical and Electronic Engineers (IEEE) credits eight "firsts" to SIGSALY:

1. first realization of enciphered telephony
2. first quantized speech transmission
3. first transmission of speech by Pulse Code Moduation (PCM)
4. first use of companded PCM
5. first example of multilevel Frequency Shift Keying (FSK)
6. first useful realization of speech bandwidth compression
7. first use of FSK-FDM (Frequency Division Multiplex) as a viable transmission method over a fading medium
8. first use of a multilevel "eye pattern" to adjust the sampling intervals

1942–43 The British Foreign Service's Department of Communications constructs **Colossus**, the first fully operational, fully **electronic computing device**. A powerful cryptoanalysis tool, Colossus operates in binary, reads incoming data from punched tape, and is controlled by hundreds of vacuum tubes that serve as switches.
(Christos J. P. Moschovitis, Hilary Poole, Tami Schuyler, Theresa M. Senft, *History of the Internet: A Chronology* [1999])

1945 Introduction of the **atomic bomb** at Hiroshima.

Arthur C. Clark proposes a geosynchronous satellite.

Engineer **John Bardeen**, with **Walter Brittain** and **William Shockley**, attempts to apply semiconductors to electronics. Semiconductors, such as silicon, are materials whose conductivity can be deliberately or predictably altered using electricity.

1952 **Alan Turing** is convicted of indecer (homosexual activity and is sentenced to large doses of oestro

1945 **Vannevar Bush** describes Memex, the **first personal computer** (in theory), in the *Atlantic Monthly*. The article later reappears in the widely distributed *Life magazine*. Memex is a desk that contains large amounts of information compressed onto microfilm. The user sits at the desk, swiftly accessing information by operating a board of levers and buttons. The desired information appears on translucent screens propped on the desktop. (Christos J. P. Moschovitis, Hilary Poole, Tami Schuyler, Theresa M. Senft, *History of the Internet: A Chronology* [1999]).

1945 **ENIAC** (Electronic Numerical Integrator and Computer) is unveiled in a basement room at the University of Pennsylvania. It covers 650 square feet and contains 300 neon lights, 10,000 vacuum tubes; 220 fans are required. The massive computer can carry out 5,000 operations per second. ENIAC can calculate the speed of a flying object faster than the object can fly.

1945 **John von Neuman** publishes a report on **EDVAC** (Electronic Discrete Variable Automatic Computer). Von Neuman outlines "**stored-program-computing**" for the first time: the computer's storage device houses the program's instructions along with the imput data. Thus, more memory is available. Von Neumann also coins the now-universal computing terms: memory, input and output, organs, and gates. (Christos J. P. Moschovitis, Hilary Poole, Tami Schuyler, Theresa M. Senft, *History of the Internet: A Chronolgy* [1999])

1946 CBS demonstrates **color TV** to journalists and the FCC in the Tappan Zee Inn at Nyack-on-the-Hudson, New York.

1947 Walter Brattain and John Bardeen of Bell Telephone Laboratories devise the **transistor**, an electronic switching mechanism and amplifier (to replace vacuum tubes). "The first transistor, the point-contact transistor, stands ten centimeters high – contains a semiconducting crystal of germanium, which serves as the amplifier, connected to 3 wire probes. A current entering one probe is amplified when it passes through the crystal and out through another probe." (Christos J. P. Moschovitis, Hilary Poole, Tami Schuyler, Theresa M. Senft, *History of the Internet: A Chronology* [1999])

1950 **First US cable television** system appears.

1946 **Whiteside Parsons**, a devotee of Aleister Crowley's magick and a brilliant scientist at the Jet Propulsion Laboratory in Pasadena, CA, attempts to create a homunculus, literally an artificially conceived person occupied by a preterhuman spirit. Among the oldest of alchemical legends, Crowley's Moonchild suggests that a homunculus could be created when both parents were Crowleyan initiates who performed the required sex magick rituals. The embryo created by their congress would act as a "butterfly net" to capture the appropriate spirit. The resultant child would be human in the commonplace biological sense but for all pragmatic occult purposes would function as a homunculus. After the appropriate chants, intonations, and gestures, Parsons and Marjorie Cameron commence sex magick congress in the presence of L. Ron Hubbard, who describes the activity taking place on the astral plane.
Tragically, on June 20, 1952, Parsons is blown apart by an explosion in his garage. Bloody body parts are visible in the rubble. Today Parsons is credited with aiding in the creation of solid rocket fuel, which is commonly used in space exploration. A crater on the moon is named after him, honoring his achievements in this field. (Bill Landis, *Anger: The Unauthorized Biography of Kenneth Anger* [N.Y.: Harper Collins, 1995])

1950 EVP (**electronic voice phenomena**) Latvian psychologist **Konstantin Raudive** experiments with electronic communication with the dead. Raudive sits alone and asks questions of departed friends and loved ones, while an ordinary audio tape recorder is used to record the session. He lets the tape machine record sounds in his laboratory for several hours, monitoring it. After repeatedly listening to the tapes he is able to discern responses to his questions from the dead. The dead explain that they can modulate sound waves with their thoughts to simulate voice patterns. They tell him to turn on a radio in the laboratory and tune it between stations, where static or white noise is present. They then use the vibrations of the white noise, which contains the full spectrum of audible sounds, to create words. They also say they have developed an apparatus that helps them to make the voice patterns audible.

1947 **Dennis Gabor** describes principles of **holography**.

1948 Ampex Corporation markets **first commercial video tape recorder**.

1954 **Alan Turing** eats half an apple dipped in cyanide and dies.

1957 **Sputnik**, first **satellite**, launched by the Soviet Union [Union of Soviet Socialist Republics]. The satellite, a metallic object the size of a beach ball, rotates around the earth for three months and then falls – it burns up when it hits the atmosphere.

1960 **First ruby laser** built by **Theodore Maiman**.

1961 **First manned space flight**.

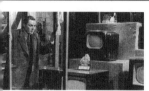

Anthony Pelissier, *Meet Mr. Lucifer*

The film *Meet Mr. Lucifer* features a moral-tale of television as "an instrument of the a mechanical device to make the human utterly miserable."

1954 **Lawrence Curtiss**, an undergraduate physics student, invents a process by which fine glass fibers can be coherently bundled in order to convey an entire image: the **Fiberscope**.

The Dataphone, the first commercial modem, designed by Bell Labs

1958 Researchers at Bell Telephone Laboratories invent the **modem**, short for modulator-demodulator. The device converts data from the computer format (digital) to the telephone-line format (analog) and back again. Modems make computer networks possible. (Christos J. P. Moschovitis, Hilary Poole, Tami Schuyler, Theresa M. Senft, *History of the Internet: A Chronology* [1999]).

1959 **Robert Noyce** of Fairchild Semiconducutor and **Jack Kilby** of Texas Instruments simultaneously design the integrated circuit, later known as the **microchip**. The transistor is miniaturized into a tiny pattern etched onto a slice of silicon, becoming the integrated circuit. This development makes it possible to create much smaller versions of electronic devices, eventually including the microprocessor and personal computer.

1962 Computer engineer **Paul Baran**, in the paper "On Distributed Communication Networks," describes what later becomes known as **packet switching**, in which digital data are sent over a distributed network in small units and reassembled into a whole message at the receiving end. The network is designed to improve the security of strategic weapons communications systems that are vulnerable to nuclear attack. The new systems would function even if some of its sub-components were destroyed: 1) Instead of a common decentralized network (telephone system), several interconnected main centers are linked like a net, each location connected only to its immediate neighbors; messages have multiple pathways by which to reach their destinations and can always be rerouted. 2) The system chops up the message and sends each piece by a different route.

1963 The American National Standards Institute renders the **ASCII character table** as the standard character representation system for the computer industry. Computers use the binary system, in which numbers are represented by sequences of ones and zeros, to store, process, and exchange information. Programmers use other characters. A translation process is required. ASCII assigns a particular binary number to each character of the alphabet (A = 1000001).

1958 Color is synthesized from a monochrome television set in the first "**flicker color**" broadcast.

1958 *Kukla, Fran and Ollie*, a children's show, begins color television broadcast.

1958 Pope Pius XII declares Saint Clare of Assisi the patron saint of television.

Three Faces of Eve, 1957

1957 A conversation between **Jerry Lee Lewis** and **Sam Phillips**, owner of Sun Records:
SP: You can save souls! JLL: No! No! No! No! SP: Yes! JLL: How can the Devil save souls? What are you talkin' about? I have the devil in me! If I didn't, I'd be Christian! SP: Well you may have him – JLL: JESUS! Heal this man! He cast the Devil out, the Devil says, "Where can I go?" He says, "Can I go into this swine?" He says, "Yeah, go into him. Didn't he go into him?"

1957 Release of *The Three Faces of Eve*, the first movie about multiple personality disorder, based on the best-selling book of the same name.

954 Clarence Kelly Johnson designs the Utility-2 (U-2) Jet for Lockheed Aircraft and dubs it "The Angel". The Hyon Corp. develops the "B-camera" for the U-2. Its mylar film and lens (conceived by Dr. James Baker of Harvard) can photograph the entire US in just 12 flights and can resolve a 2x2 ft. object from a thirteen-mile altitude.

1956 Emmett Norman Leith develops the **data processing system** that allows **holography** to work. Holography is the recording and reconstruction of a wavefront. The reconstructed hologram wavefront is identical to that which issued from the object.

1960 **First successful hologram** produced.

1965 **Larry Roberts**, a young computer scientist at Lincoln Laboratory in Boston, creates the **first long-distance computer connection**, a rudimentary telephone link between his computer and one in Santa Monica, California.

1965 **Ted Nelson** introduces the terms **hypertext** and **hyperlink**, thematic links between documents, to refer to the structure of a theoretical computer-ized information system called Xanadu that would be organized associatively, not sequentially.

1965 Psychologist **Tom Marill** propos-es that ARPA fund a long-distance computer between MIT's Lincoln Laboratory's TX-2 computer and System Development Corporation's Q-32 in CA. The link allows the machines to send messages to one another. The device that connects the computers to phone lines works badly, but it works.

1966 **The first video game** is created by engineers at Sanders Associates, a New Hampshire-based defense contractor. **Ralph Baer** conceives the design. He recalls: "I'm... thinking about what you can do with a TV set other than tuning in channels you don't want." The first toy Baer and Bill Harrison make consists of a lever that players pump furiously to change the color of a box on a television screen from red to blue. The first games are all two-person games in which players control every object on the screen.

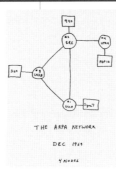

A sketch of the original ARPAnet structure as outlined by Larry Roberts

1969 **ARPAnet** prototype of the Internet is initiated.

UNIX
LIVE FREE OR DIE
TRADEMARK OF BELL LABS*

The Unix operating syste

1969 **First manned landing on the moon** Apollo 11 mission is trans-mitted and broadcast live from the moon.

1965 **Early Bird** (Intelsat I), the **first telecommunications satellite**, is launched; live video feeds from all over the world begin.

1966 NASA launches five Lunar Orbiter satellites. Together they photograph the entire moon.

1971 Latvian psychologist **Konstantin Raudiv** publishes the English translation of his book *Break Through: Electronic Communication with the Dead May Be Possible*. Raudive chronicles his own research conducted in the 1950s.

1967 Sony introduces the Portapak, **first portable video recording system**.

1969 Glenn McKay creates **psychedelic light shows** for rock bands that combine the live manipulation of pigmented liquids and film projection systems.

1977 **Apple** introduces **home computer**; the company logo depicts a rainbow-colored apple with one bite taken out of it.

1980–85 Scitex, Hell, and Crosfield introduce **computer-imaging systems**.

1987 FBI creates **Carnivore**, a clandestine system for sifting through e-mail on the Internet. Carnivore software runs a packet-sifting program, which notes all messages inside the ISP network by origin and destination. Thus the FBI can extract and read messages of interest.

'Hijacking the Net' front cover of *Newsweek*, February 2000

1974 US Air Force Development Test Center, Eglin Air Force Base, Florida, begins developing the weapon system to be popularly known as the **Smart Bomb**. The bomb is guided by a television Electro Optical TV via Mid-course guidance Beacon Data Link during the day, and an Imaging Infrared Seeker via Beacon Data Link during the night. Live images from a camera in the bomb are sent to a remote operator, who uses them to guide the bomb to a target.

1981 **MTV** begins broadcasting.

1975 It is now estimated that by the time a person reaches eighteen years of age, he or she has, on average, attended school for 10,800 hours and watched television for 20,000 hours.

1977 SMTE (Society of Motion Picture and Television Engineers) recommends the use of the **color bar** for registration of color on TV.

1988 **Red-eye reduction** is used in cameras.

The robotic figure of actress in *The Exorcist*

1973 *The Exorcist* is one of the top-grossing films of the year. It is said to be based on the true story of the demonic possession of a fourteen-year-old boy. Set in the Georgetown district of Washington, DC, the film uses graphic, violent scenes including special effects to depict the exorcism of a young girl. The film is terrifying to audiences, and there are reports of fainting. More serious are accounts of cinematic neuroses, as previously unidentified psychiatric patients claim to be possessed. Classical symptoms and disabilities are observed in audiences after viewing the movie. Psychiatrist Bozzuto suggests that the loss of impulse control depicted in some scenes may threaten people with similar problems by exceeding their "stimulus barrier."

1977 Rumors surface that accuse **McDonald's** fast-food restaurant of donating a percentage of its profits to the Church of Satan. The corporate logo of golden arches is said to be a symbol of the gates of hell. People are said to have seen and heard Ray Kroc, company founder, admit to the truth of these charges on a popular TV program, although no factual record is ever found.

1982 The film *Poltergeist* features a television set as a portal from which evil spirits are able to enter a suburban home and destroy the family.

1986 On October 4, the Transcommunication Study Circle of Luxembourg (CETL) receives its **first video image of its spirit partners**. Jules and Maggy Harsch-Fischbach record it on a VHS recorder with a Panasonic A-2 video camera. The image of a man, Pierre K, appeared on the TV screen for a duration of 4/50ths of a second. "Using high-tech communication the dead are now transmitting information to our scientists in pictures, text, and voice via television screens, computers, and telephones. Technology allows people without bodies to communicate" (Jules and Maggy Harsch-Fischbach of CETL).

CETL suggests that there is a parallel communications lab in the spirit world: Timestream Space Lab. The facilities are located in the third plane of the astral world on a planet named Marduk. The Spirit-side technicians state; "We have a body like yours. It consists of finer matter and vibration than your dense, coarse physical bodies. There is no sickness here. Missing limbs regenerate. Bodies that are disfigured on Earth become perfect. We live in comfortably furnished houses. We soak up noise, such as hiss between radio stations, and turn it into artificial voices."

1980 Publication of *Michelle Remembers*, in which Michelle Smith and her psychiatrist, later her husband, tell of her escape from a cult and of the extreme **satanic ritual abuse** she suffered at its hands. The book sparks a flood of similar accounts, which increases over the next decade. A template narrative of ritual abuse is repeated under hypnosis to psychiatrists from coast to coast. The narrative involves these repeated elements: satanic rites, rape, kidnapping, and forcing the victim to kill an infant. Law enforcement finds no evidence to support the claims.

1980 Sony demonstrates **first consumer camcorder**.

1994 **CU-SeeMe**, a live video streaming program for the Internet, is developed at Cornell University. The program allows anyone to broadcast in cyberspace.

1996 **Jennicam**. A 23-year-old exhibitionist launches a web-site featuring real-time video of her mundane daily activities. She develops a large following.

1996 **Cookie**: a piece of information generated by a web server about the user's preferences are secretly stored in the user's computer. Cookies are swapped back and forth between the web servers and the user's computer without the user's consent or knowledge. As a result personal information of all sorts can be transmitted to web servers.

1996 **Dildo Cam** is a ubiquitous feature of pornographic web-sites. Short videos, usually available by subscription only, allow the viewer literal access, via video, into the vaginas and rectums of porn stars.

Dildo Cam advertised on web-site

1991 **Gulf War** news coverage is highly controlled by the US government. Video footage from cameras in the tips of the GBU-15 smart bombs, which features views of their rapid decent to their target, is released to the media. **Weapon video** is either electro-optical (TV camera) or infrared and is generated in the nose of the weapon. The laser guidance system can bring the bomb within four yards of the target.

1995 An **ATM camera** records a Ryder truck outside Oklahoma City's federal office building just before the blast that kills 167 people. That image helps police track down bomber Timothy McVeigh.

1997 Six hundred Japanese children and a few adults are rushed to emergency rooms after watching the television program *Pocket Monster* (**Pokémon**). The flashing red eyes of the cartoon monster cause some viewers to fall into convulsions. One person in 200 suffers from epilepsy, and of those, 5 percent have photic seizures, which may be provoked by frequencies of 5 to 30 flashes per second. Other triggers may be: TV and computer screens, video games, faulty screens and lights that flicker, sun shining through a row of trees viewed from a passing car, looking out of a train window, sunshine on water, stroboscopic lights, and geometric shapes or patterns.

1989 **Parents Music Resource Center** (PMRC) is set up by Tipper Gore, the wife of future Vice President Al Gore, to lobby the US government for the **censoring of the music industry**. At congressional hearings she states that heavy metal and rap music is "dangerous to the children of America." The music industry agrees to self-regulation and adopts a sticker system to warn of offensive content.

1990 **Ritual abuse** causes a total reassessment of psychiatric technique and casts great doubt on the field of dissociative identity disorders.

1990 **Judas Priest**, a heavy metal band, is cleared of charges that their music contains **subliminal messages** inserted through the technique of backward masking (messages recorded in reverse embedded in songs). Allegedly, these messages have provoked the tragic suicide of two young fans.

1992-94 **Black metal rock groups** in Norway, aligned with Finland's pagan past and Satan worship, incite the burning of twenty churches, and rival band members commit murder and suicide.

1991 **Procter & Gamble** announces that it will change its logo. The graphic man-in-the-moon with thirteen stars is to be redesigned in response to years of protest that the logo was a satanic symbol. Since the early 1980s the image has been said to involve the Antichrist: when looked at from certain angles it looks like a 666; the man-in-the-moon's hair forms the devil's horns; his beard when viewed in a mirror reveals 666; the stars when connected by three curved lines form 666. The following is a recording of a conversation from the Procter & Gamble product information phone line in 1989:
Customer: What about the logo, I'm worried about it...
Procter & Gamble: Oh, that's just a cute little logo.
C: Where did it come from?
P&G: Over one hundred years ago it was used on the docks to identify our products, it was stamped on the crates...
C: Was there... is there anything... ?
P&G: No, there's nothing satanic or evil about it, it's just, like, a cute little symbol, like a smiley face or something, it's just a symbol...

1999 **voyeurdorm.com**, a "reality based" web-site goes online. "Six 'students' live in a house with 40 webcams. For $34 a month, you can watch their daily activities: smoking, sleeping, urinating, bathing. The rules: no sex, but masturbation is okay; no drugs, but booze is allowed; absolutely no moving the cameras away from you; no skipping out on the daily chat sessions; no boyfriends after 11 p.m.; and most importantly, no leaving the house without consent, except for the two nights a week each resident has off." (Mark Boal, "Behind the Cams at Voyeurdorm: Surveillance Sorority" [*The Village Voice*, August 4, 1999])

Endoscope, pill camera

1999 New York Civil Liberties Union volunteers walk the streets of Manhattan in search of every **video surveillance** camera, public or private, which records people in public spaces. Volunteers produce a comprehensive map of all 2,397 surveillance cameras.

1999 **Live slow motion**. Lene Vestergaard Hau slows down a light pulse from 300 million meters per second to 17 meters per second by passing it through a cloud of laser-tuned sodium atoms chilled to less than 50 nanokelvins. Optical properties of materials can be altered with this process, she states; "It's really opened up a lot of new exciting things that you can start doing."

2000 **Professor Paul Swain** invents the **endoscope**, a camera in a pill or capsule 11 mm by 30 mm, it includes a tiny light source and transmitter. It radios images from inside the body to a portable recorder strapped to the patient's waist. The pill camera is eventually excreted.

2000 **Sikorsky helicopter** company constructs a remote controlled, pilotless helicopter drone called the **Cypher**. It looks like a flying saucer and uses commercially available people-tracking software to find human targets in urban riot situations.

2000 **Ensormatics**, a leading manufacturer of **surveillance cameras** that built its $1 billion international business on anti-shoplifting technology, estimates that 62 percent of middle- and high schools will implement some form of electronic security by 2002.

2000 **Fluorescent Green Jellyfish/Monkey Embryo** is created in a lab. Scientist Gerald Schatten, of the Oregon Primate Research Center at Oregon Health Sciences University, introduces jellyfish genes into the developing embryos of Rhesus monkeys. The gene encodes instructions for a protein that gives the jellyfish a green glow. When fluorescent light is shined on the embryos "more than a third of embryos fluoresced." Although the genes are not found in the monkeys after birth, scientists say it is just a matter of time before the procedure will work for primates, including humans. The technique also works with mice. Ryuzo Yanagimachi and his colleagues at the University of Hawaii mix the same jellyfish gene with mouse sperm, injected the sperm into mouse eggs and created embryos. After the birth of the mice, Yanagimachi detects a green glow in the tails of the mice under a fluorescent light.

Acknowledgements

Tony Oursler The Influence Machine is published in relation to the installation with the same title that was presented by the Public Art Fund in Madison Square Park in New York between 19 and 31 October 2000, and by Artangel in Soho Square in London between 1 and 12 November 2000.

The Influence Machine was co-commissioned by Artangel, London, and the Public Art Fund, New York.

The Influence Machine
Actors: Constance DeJong, William Kirkley, Tracy Leipold, Linda Leven, John McCausland, Shamel Moore, Belinda Wilson & Wilson family.
Music composed by Tony Conrad
Music recorded by Dean Shostak

Public Art Fund
One East 53rd Street
New York, NY 10022
tel + 1 212 980 4575, fax + 1 212 980 3610
info@publicartfund.org
www.publicartfund.org

Artangel
31 Eyre Street Hill
London EC1R 5EW
tel + 44 20 7713 1400, fax + 44 20 7713 1401
information line + 44 20 7713 1402
info@artangel.org.uk
www.artangel.org.uk

Public Art Fund

Board of Directors:

Susan K. Freedman *President*

Gerald A. Blitstein, Jenny Dixon, Joan Feeney, Barbara Joelson Fife, Sara Fitzmaurice, Lloyd Frank Esq., Patricia E. Harris, Matthew Harris, Ronald Jones, Richard Kahan, Marilynn Gelfman Karp, Abby Kinsley, Allen Kolkowitz, Ronay Menschel, Suzanne Randolph, Charles Short, Erana Stennet, Billie Tsien, David Wine

Tom Eccles *Director*

Malia Simonds *Administrative Director*
Richard Griggs *Project Director*
Anne Wehr *Communications Manager*
Margaret Wray *Development Co-ordinator*
Miki García *Project Co-ordinator*
Mayuri Amuluru *Administrative Assistant*

For the installation of *The Influence Machine* in New York:

Zoe Pettijohn *Production Manager/ assistant Tony Oursler*
Theo Angell, Casson Demmon, Douglas Scott, Dave Hurwitz, William Kirkley, Pravin Sathe, Sean Souza, Todd Stewart, David West, Nancy Whang, Rainer Quitsow *Technicians/Invigilators*

The Influence Machine was presented in New York with sponsorship from TARGET.

Artangel

James Lingwood & Michael Morris *Co-Directors*
Antoinette O'Loughlin *Head Admin & Production*
Melanie Smith *Production Co-ordinator*
Milly K. Momin *Financial Manager*
Francesca Laws *Admin & Project Assistant*
Gerrie van Noord *Head Artangel Publishing*
Samira Kafala *Press & PR Consultant*
Kathy Battista *Interaction Co-ordinator*
Natalie Kancheli *Development Co-ordinator*

For the installation of *The Influence Machine* in London:

Simon Corder & Simon Byford *Production Management*
Melanie Smith *Production Co-ordinator*
Ben Borthwick *Production Assistant*
Ruari Cormack *Chief Technician*
Lorraine Selby *Front of House*
Simon Hamilton, Phil Hill, Barbara Egervary, Michael Krüger, Deklan Kilfeather, John Tiney, Jason Davidge, Keith Roberts, Charlotte Wales, Vicky Parker, Darryn de la Soul *Technicians/Invigilators*

With thanks to
RSVP Limited, Dimension Audio, White Light, First Network, Dovetail and Blitz for equipment hire.

The Influence Machine was presented in London as the Beck's/Artangel Commission with the support of London Arts, the City of Westminster, Beck's, the Stanley Thomas Johnson Foundation, the Henry Moore Foundation, the Calouste Gulbenkian Foundation and the private patronage of The Company of Angels, with the special help of Tom Bendhem and Anita and Poju Zabludowicz.

Artangel is a registered charity, no. 297976.

ISBN 1 902201 11 6

Edited by Gerrie van Noord
Designed by Mark Diaper, Berlin

Photography:
New York; Aaron Diskin, Tony Oursler
London; Hugo Glendinning, Phil Lea, Parisa Taghizadeh
Video stills: Tony Oursler

Printed by Medialis, Berlin

Distribution

UK & Ireland
Cornerhouse Publications Ltd.
70 Oxford Street
Manchester M1 5NH
tel + 44 161 2001503
fax +44 200 1504

Continental Europe
Idea Books
Nieuwe Herengracht 11
1011 RK Amsterdam
The Netherlands
tel + 31 20 622 6154
fax +31 20 624 7336

Americas
D.A.P.
2nd Floor, 155 Sixth Avenue
New York, NY 10013, USA
tel + 1 212 627 1999
fax +1 212 627 9484

Printed and bound in Europe